"*Jason Inman provides a manual which utilizes and analyzes subtext to offer psychological profiles of our favorite superheroes, viewed in the context of their fictional experiences as warriors and veterans in the US armed forces. He demonstrates vividly and entertainingly how the superhero pantheon is firmly rooted in the disciplines, lore, and traditions of American combatants throughout history. The creators of all these characters took a good look at real-life military heroes for their inspiration, and now Mr. Inman makes this link clear.*"

—Dan Aykroyd, actor/writer of *Ghostbusters* and *The Blues Brothers*

"*Finally, someone takes a deep dive into two of our best American institutions. From Captain America to the rest of this elite unit, get ready to salute.*"

—Brad Meltzer, bestselling author of *The First Conspiracy*

"*An inspiring reflection on the impact our brave men and women have had on pop culture and the heroes we see on the pages and the big screen.*"

—Jen Griswold, CEO and author of *Mission Entrepreneur*

"Super Soldiers *is a hell of a fun book and with it Jason Inman has written a love story to soldiers, to comic book heroes, and to his country. Witty, fast-paced, and nerdy (I mean learned) on his subject, Inman is a perfect guide for a deep dive into the interwoven historiographies and mythologies of American warriors and pop culture. Every American must ask: will I wear tights today or will I wear digi camo? Inman lets us have it both ways."*

—Anthony Swofford, former US Marine and author of *Jarhead*

"*Not all heroes wear capes...but some do. Jason Inman's* Super Soldiers *is a brilliant examination of fictional service enlisted in very real wars. A topic near and dear to my heart and, one chapter in, you'll realize that Inman's words are ALL heart.*"

—Mitch Gerads, coauthor of *Mister Miracle* and *The Sheriff of Babylon*

"*Inman brings more insight to the superhero genre than any writer, fan, or critic ever before. A truly thoughtful look at the tradition of heroism in the face of war.*"

—Joshua Hale Fialkov, writer of *The Bunker*, *Tumor*, *I, Vampire*, and *The Ultimates*

"*Having worked with military charities for a decade now, I know how real the connection is between costumed heroes and the everyday heroes of our country. In this informative and funny book, Jason Inman highlights that connection for people who may have never known of its existence. We have our vets to thank for the Marvel Universe (both Stan Lee and Jack Kirby served), and we have Jason to thank for this book that acts as a love letter to the patriot comic book characters of the past and present.*"

—B. J. Mendelson, comic book writer and author of *Social Media Is Bullshit*

"*A wide-ranging mix of comic book history and autobiography, Jason Inman's* Super Soldiers *intelligently examines the lives of superheroes through the lens of their own military service. Inman's personal experiences in the US Army lend a fresh and unique take on several major heroes, and his comic book commentaries are full of razor-sharp wit.* Super Soldiers *provides a wonderful overview of the uniformed men and women who have dedicated their lives in service to our country…even if only in the pages of a comic book!*"

—Sterling Gates, screenwriter, producer, and comic book writer

"*Jason's experiences as both a dedicated soldier and serious comic book geek make this an unforgettable read. As informative as it is entertaining,* Super Soldiers *gave me a deeper appreciation for the heroes that I love and the values they inspire. It should be required reading for every comic fan.*"

—Samm Levine, actor in *Freaks and Geeks* and professional nerd

"*Jason Inman, I salute you. This is a heroic, inspiring, smartly researched, deeply personal, and historically relevant book that manages to be as thrilling as it is thoughtful.*"

—Benjamin Percy, writer of *Wolverine*, *Green Arrow*, *Teen Titans*, and *Nightwing* and author of *The Dark Net*

"*The relationship between America's superheroes and service members has existed almost as long as the comics medium itself. The connective tissue between the two has changed and morphed over the years, as have our perceptions regarding America's role in global conflicts. Jason Inman's in-depth examination of this fascinating topic is a remarkable study of our country's heroes, both real and imagined, and their compelling links, through the ever-changing course of our nation's military history.*"

—Dan Jurgens, writer/artist of *Superman* and *Captain America* and creator of Booster Gold

"Drawing from his own military experience and his clear love of comic books, Jason Inman crafts a heartfelt and humorous (though no less gloriously nerdy) overview of superheroes who have served their country."

—Joseph Mallozzi, writer/executive producer of *Dark Matter*, *Stargate SG-1*, *Stargate Atlantis*, and *Stargate Universe*

"What I love most about Super Soldiers—and there's a lot to love—is Jason Inman's thorough joy and passion. Both burst onto the page, making for one compelling, and important, read."

—Michael Moreci, writer of *Wasted Space* and *Star Wars* and author of *Black Star Renegades*

"Jason does what few can—he takes his own stories of service and weaves them into complex looks at the heroes we've all grown up reading, and continue to enjoy to this day. Comparing his guard duty with Captain America's? Explaining how the US Air Force values are intrinsic to Captain Marvel's ethos? Demonstrating how John Stewart being a marine makes him a better Green Lantern? These are enthralling character studies that no one else can pen, and it's why I loved Super Soldiers."

—Greg Miller, cofounder of KindaFunny.com

"During my childhood, my world revolved around superheroes. Countless hours were spent reading, watching, and drawing any- and everything related to the world of capes and tights. Of course it was easy to get lost in all of those various tales of cosmic rays, radioactive spiders, and speeding faster than bullets, but I believe it was their common thread that resonated most deeply. All of those heroes used their extraordinary abilities to defend the defenseless against those who would do them harm. They put their lives on the line to oppose evil, not for thanks, but because it was the right thing to do.

"Growing up as the son of Master Sergeant John H. Sands, I learned early on that there was a commonality between those who wore costumes in comics and those men and women I saw every day in uniform. I came to know that the same people that we passed in the commissary actually possessed a superpower: bravery. If called upon, they were willing to make the ultimate sacrifice in order to uphold those self-evident truths that our country was founded upon

Super Soldiers *shines a spotlight on several beloved comic book superheroes (and a few villains) who were once counted among the ranks of the US armed forces. Jason's prose informs who these characters are to a great degree and in many cases, why they've endured for decades."*

—Ryan Sands, artist/actor on *Marvel's Runaways*

SUPER SOLDIERS

SUPER SOLDIERS

A Salute to the Comic Book Heroes and Villains Who Fought for Their Country

Jason Inman

Mango Publishing
CORAL GABLES

For permission requests, please contact the publisher at:
Mango Publishing Group
2850 S Douglas Road, 2nd Floor
Coral Gables, FL 33134 USA
info@mango.bz

For special orders, quantity sales, course adoptions and corporate sales, please
email the publisher at sales@mango.bz. For trade and wholesale sales, please
contact Ingram Publisher Services at customer.service@ingramcontent.com or
+1.800.509.4887.

Super Soldiers: A Salute to the Comic Book Heroes and Villains Who Fought for
Their Country

Library of Congress Cataloging-in-Publication number: 2019938547
ISBN: (print) 978-1-63353-994-5, (ebook) 978-1-63353-995-2
BISAC category code: SOC022000, SOCIAL SCIENCE / Popular Culture
Printed in the United States of America

For Bernadette Inman—my dear mom—who created my love for books, and for the veterans and service members of the US armed forces, whose bravery and courage should never go unrecognized. I count myself lucky to call you my brothers and sisters.

Table of Contents

Introduction

There's a surprisingly high amount of crossover when it comes to camouflage and spandex. It's quite shocking, actually. Both are machine-washable, they are staples of '90s hip-hop fashion, and, probably most importantly, both are worn by heroes. In all seriousness, the pages of comic books are littered with men and women who have signed on the dotted line and put on the uniform of the United States military.

But why? Why are comic books filled with so many service members? The mental fortitude required to pull off wearing your underwear on the outside of your costume is at least comparable to the courage President Teddy Roosevelt displayed when he charged up San Juan Hill. Both service members and comic book characters pull off amazing feats that seemed nigh impossible. One could make the easy comparison that both sides are filled with heroes. Superheroes put on their capes and boots and dive off rooftops in a never-ending quest to save everyday citizens in the service of justice. Military soldiers do the same (without the capes, of course). Whether it is duty, responsibility, or classic patriotism, these men and women have laced up their boots and sacrificed their lives to protect civilians they have never met.

However, there are many differences as well. Most comic book heroes are vigilantes. They can't be tied down by any law or institution because the actions they need to take (for the good of their community) have to be done "outside the law." Superman can't join the military—what if he needed to stop a flood in a country that wasn't an ally of the US? This allegiance would tie his hands. Superman is going to fix a dam in whatever country he pleases. And he should. He's Superman.

Service members have to follow a different code. One must raise their right hand, swear an oath of enlistment to the values of the United States, and obey the orders of the officers appointed over them—this oath leaves very little wiggle room. A soldier cannot do as they please. A soldier cannot save whomever they want.

How could anyone uncover this commonality between soldiers and comic book characters, you might ask? Well, as an Operation Iraqi Freedom Army veteran, comic books were one of my small pleasures in a very harrowing time.

The year was 2005, and I was stationed in Tallil Air Base, which is located near Nasiriyah, Iraq. I didn't stay at the air base long, as many missions had our rear ends constantly parked inside a fully-armed Humvee. I had fallen away from the comic book world in the years leading up to 2005. Occasionally, when the big comic events hit, I would poke my head back into the world of capes and tights, but mostly I stayed away. Comic books were just a nostalgic thing harking back to my childhood at that time. During my mom's shopping trips when I was a kid, I would demand she inspect the grocery store's comic rack to pick up the latest issue of Iron Man. In 2005, that was no longer the case. She had refused to make these trips for me long before.

One of the biggest enemies you have to fight, as a soldier deployed overseas to a combat zone, is boredom. You're far from home, living in a strange place, and driving down to the local bar to hang out is impossible. Internet access was very limited at that time, and smartphones were still to come. At the forward operating bases where missions were assigned, recreation time was (and is) very limited. Here we were, over 150,000 members of the US armed forces, parked on a stretch of Iraqi desert no one had occupied for years. Not exactly a prime location, but the camels seemed to like it.

When we drove "outside the wire" (our term for leaving the safety of our forward operating base), we had nothing except what we could carry with us. Passing time was an eternal struggle between reading the same paperback novel for the fifth time and staring into the sky for hours. Our cloud-naming contests were epic. In the end, comic books changed all that for me.

Inside a care package from one of the many charitable groups in support of troops, I found an issue of *Ultimate X-Men*. This new take on the classic mutant team intrigued me. Why did they all have black costumes? Why did the X-Men finally act like cool teenagers? And—most importantly—why did Wolverine have a goatee? I needed to know how the story ended, so I immediately penned a letter to my parents asking for subscriptions to all the Marvel Ultimate Universe titles...and to have the issues shipped to me in Iraq.

Ever since then, comic books and soldiers have been tied together in my life. It's the same link that led me to create my annual Comic Drive for Service Members with Operation Gratitude—four successful years so far! This link has led me to write the book you now hold in your hands. My arrogance and passion have combined to decide the world must know about the secret link between comics and the military! There's no better way to illustrate this than to examine the comic book superheroes who have served. Why did they put it all on the line for their country? What does their wartime experience tell us about them? How does it inform their comic book adventures?

All that led me to the simple truth: I would have to create an epic list worthy of the US armed forces. (Sadly, I had to limit my list to the United States. While there are many comic characters who served in foreign armies, I only have expertise in my home country.) How does one compile a list of sixteen comic-book

service members to write about? It was not a simple task, although the first choice for this list is one that I hope all comic book fans can agree on. It's not Superman; he never served. That Kansas farm boy decided writing newspaper articles was more important.

The most obvious choice for this book is Captain America. He is not only a comic book character, but such a true-blue soldier, he dyed all his clothes in the colors of the American flag and earned himself the prestigious honor of being the subject of my first chapter.

I compiled the rest of the list by pulling everything from the clear choices to the unknowns who had served in alternate or previous versions of their origins. All of these characters have harnessed the principles and fortitude learned in service to this great country of ours to better protect the people as costumed heroes. Yet not all comic book soldiers are honorable people. Sometimes they fall. Sometimes their missions overseas never end, and can affect their mental well-being for their entire life. I want to dive into these men and women too—these characters are some of the best, just as some are examples of the worst.

This book will strive to examine the ways in which comic books portray soldiers, marines, airmen, and sailors. It strives to shine a light on how some comic book readers may see soldiers through the lens of their funny book pages. It will illuminate how their service can be used in a positive light, a way to enforce and increase a character's heroic nature. It will prove that these two professions create a kind of *simpatico*.

Please enjoy this mix-tape of comic book characters who began their heroic or villainous careers as service members. I sincerely hope this examination will affect you and bring clarity to the great sacrifice many service members take on when they enlist

in the armed forces. Those men and women are the true heroes, and I find it fascinating that their traits have been used to propel the fictional superheroes on many panels throughout numerous comic pages.

Chapter 1

Captain America

The Perfect Soldier

We know Captain America like we know the American flag. We may not personally know all his stories or his ideals, but we can all see the design of his costume clearly in our minds. The tiny wings that stick out on the side of his mask, the red and white stripes across his perfect abs, and his daring red pirate boots that marched up the beaches of Normandy on D-Day. It's impossible to forget the pure saturation of America that is Steve Rogers.

Before I began researching the star-spangled Avenger to prepare for this book, I already had some preconceived notions about the man known as Steve Rogers. He was brave, loyal, and true. Beyond his representation in the Marvel films by blonde dynamo Chris Evans, I had come to appreciate the steadfastness Cap embodied in all of his adventures. He was going to do what was right every single time, no matter the cost, and no matter how many people he had to punch to do it! Plus, can anyone explain the physics-defying mechanics of how he throws his shield, bounces it off several buildings, and still manages to catch it? If that's not 100 percent patriotic magic at work, then I don't know what is!

It is for this reason that, whenever I think of the good captain, the very first image that pops into my head is the cover to *Captain America Comics #1*. Released in 1941, this cover features Captain America socking Adolf Hitler in the jaw, as Cap's good pal and sidekick, Bucky, salutes the camera as if to say, "Job well done!" Even if you think you've never seen this image, I'm certain you've glimpsed it in a comic book or pop culture store at some point in your lifetime. It's iconic! The very

image of America punching evil right in its stupid face. The cover declares: "Smashing thru Captain America came face-to-face with Hitler"—and he certainly did. I like to think this image has something to do with the lasting legacy of Captain America. With a debut image this striking, how could the comic book reading audience ever forget him?

The cover's famous artists were Joe Simon and Jack Kirby (the luminary co-creator of many of Marvel's other famous creations, including Spider-Man, X-Men, and the Hulk). Simon, before his time at Marvel, was a political cartoonist and anti-isolationist. With Kirby, he cooked up the anti-Hitler cover to express their political leanings, and several readers at the time did not think this type of cover belonged on a comic book.

The cover of *Captain America Comics #1* is a clear and concise character introduction; however, the story contained inside veers off the rails in some interesting ways. We meet scrawny Steve Rogers, a boy from Brooklyn who volunteers for an insane science experiment that is going to permanently alter his life. Only a non-paranoid American story icon would volunteer to have his body pumped full of dangerous chemicals. In the years to come, when many young Americans were forced into service by the draft, Steve volunteered. Steve could have given up. However, he kept going. Driven by a need to serve his country, he was a hero before he ever became Captain America. The experiment transforms Steve into a new godlike body—he is described as the first of a corps of superagents that the United States will implement. Steve dons his star-spangled costume and does what any young, patriotic man who wanted to save his country in 1941 would have done: He stays stateside and busts up spy rings! Yeah! Wait, what?

There is no exaggeration in my previous paragraph. For the rest of the stories in the very first issue of *Captain America*, the captain never leaves America. Shocking, I know, as I bet many of you thought he would immediately join the war effort, tying his boots as he leapt into a boat headed for war-torn France. The one problem with that? America didn't enter World War II until December of 1941, and Cap's first issue debuted in March of the same year. Nine months early! All notions of Captain America immediately smashing his way into battle must be swept away. Captain America could not fight a war America wasn't a part of. Even his first encounter with the Red Skull takes place on American soil!

The most interesting thing to note about Steve Rogers in this issue is that he retains his secret identity. Steve joins the Army. He enlists as a lowly private, guarding Army camps around the nation and wearing the biggest-brimmed hat you've ever seen this side of basic training. His adventures as Captain America lead him to confront many of the same villain archetypes you would see in any superhero comic of the time. Cap was published during the "Golden Age" of comics, an age kicked off by the creation of Superman in *Action Comics* #1. The stories back then were simpler; heroes fought gangsters and villains in straightforward tales. One of Captain America's "Golden Age" stories concerns a man who makes disastrous predictions about the future; another deals with a Nazi assassin known as "The Dictator" with a penchant for chessboards. This Captain America was more superhero than soldier. Soldier was his day job. If you believed everything you read in comic books, you might come to think being a soldier in the US Army consisted of nothing but guard duty. (Which sometimes is true, but not as much as Cap's early tales would lead you to believe.)

In my entire tour of duty in Iraq, I believe I had "official" guard duty only twice. One time was on the main gate of the Air Force base we resided in, and the other was to guard our specific area of the base, called Camp Sapper. It could get really boring looking out at the sand dunes that surrounded our home base. I think I must have counted every dune at least seventeen times. Sometimes, my brain would pray for an attack—which is that last thing that anyone in a combat zone would want! Despite the hyperbole, I hope you can understand the feeling.

The early Captain America stories having nothing to do with the war shouldn't be surprising. This was a common tactic employed by many of the comic book publishing companies of the time. Publishers looked at their books as propaganda tools and morale boosters for service members. Timely Comics (the company that would go on to become Marvel Comics) had started to push anti-isolationist politics into their comics. Before Pearl Harbor, they portrayed the Third Reich as the enemy. This was popular among American readers. Many Timely Comics covers also featured Nazis as the villains. Putting provocative images on the covers of their comic books not only worked to sell issues, it also sent a powerful message to the public. The story could have little substance beyond a minor escapade, but a cover image could send shock waves.

Powerful images have always been tied to the military. I can remember, from my pre-deployment days at Ft. Sill in Oklahoma, seeing recruitment posters all over the place—well-drawn pieces of art that were usually obscured by bold block lettering. In one poster, Uncle Sam would tell us to re-enlist for the "good" of America. Another would be a sailor chastising us about "loose lips" and sinking ships. I can remember thinking, "You've already got us in. Stop advertising to us!"

I saw Captain America in exactly the same light. Without deeper research, he becomes nothing more than a symbol—a personification of the American flag that can only spout platitudes. Luckily, the character is much deeper than my basic assumptions.

Captain America #332 is an issue simply titled "The Choice." Steve Rogers is called in to a government council assembled by the President of the United States. These officials request that Captain America serve his country again in an official capacity. Reading from Cap's original Army contract, these slimy bureaucrats state that Captain America even agreed to serve as the nation's mascot back in the 1940s. Clearly, Steve Rogers needed to do a better job of carefully reading his contract when he signed on the dotted line. The government wants Captain America to work for them again, lock, stock, and barrel. However, Cap pauses. He begins a soliloquy that would bring George Washington to tears. He states that, while the US President represents the government, Captain America represents the American dream, and the American people who believe in that dream. What Captain America represents is intangible, and if he's tied to the concrete edicts of the government, he will have to violate these principles and ideals constantly.

Yes, you did read the above correctly. Captain America, the perfect soldier, just disobeyed a direct order from the United States government.

It is possible for a service member of the armed forces to refuse an order. If the order is illegal, unethical, or immoral, it is your duty to refuse and to explain why you are refusing for the greater good. You cannot state—like the many former Nazi soldiers at the famous Nuremberg trials—that you "were just following orders."

I, myself, disobeyed an order or two during my time in a combat zone. I won't go into specific details on those occasions, but let's say that, if I had followed the orders of my commanding officer, I wouldn't be writing this book right now. Back to Captain America, true believers!

Captain America was faced with an impossible choice and, instead of backing down, he stood true. The Army has a set of values all new recruits are taught. These words are drilled into any new soldier throughout their Basic Combat Training. Troops are meant to live these values every day and judge every action they take through them. The Army values are loyalty, duty, respect, selfless service, honor, integrity, and personal courage.

Steve Rogers took one big step toward selfless service in that particular story. He put the welfare of the nation before his own government. He believed he could serve his country and its people outside the purview of the government. Whether this fact is true or not, Steve grasped the idea of selfless service and did not let go.

His replacement did not do as well when faced with a similar situation. Once Captain America turned his uniform back in to the government and quit the mantle of the sentinel of liberty, the very same presidential council quickly began to search for another man. The man they found was a vigilante by the name of John Walker. John had been seeking fame as a superpowered hero, but immediately put all of that on hold when the government calls on him. He proclaims that any true patriot heeds his country's call, no matter what. When the council later delivers the news to John that they cannot meet all his conditions for taking on the position of Captain America, John solemnly delivers a "Yes, sir." No fight, no debate, merely a simple soldier's acknowledgment.

We can see the ideas of Rogers' resistance also manifest in the film *Captain America: The First Avenger*. Abraham Erskine, the scientist who has developed the super soldier serum, asks scrawny Steve Rogers if he wants to kill Nazis. Steve responds, "I don't want to kill anyone. I just don't like bullies." This answer becomes the reason Steve is chosen. Erskine instructs Steve to be "not a perfect soldier, but a good man." This is a credo all soldiers should follow. We are all human beings first, soldiers second.

Without Captain America, we would not have a model to judge all soldiers and service members by in storytelling. His legend shines as brightly as his costume. Many times, he is the perfect soldier, a military "deity" if you will, shining down from above, telling soldiers how they should act and how much courage they need to charge the next hill. Other times, he's Steve Rogers, a simple boy from Brooklyn who's going to do what's right every time. He's a perfect example, a perfect ideal, and a perfect soldier.

Captain America takes a step in the direction of being a better service member, the way I hope and dream all soldiers eventually will. At first, you join for ideals (or maybe you enlist for that sweet sign-on bonus). However you feel when you sign on the dotted line to Uncle Sam, one part of your brain has to be behind the idea of serving your country. I doubt anyone could sign any kind of contract that significant if they didn't believe in part of it. The text is full of tall orders. Soon, you will take a few steps back from the idea of glorious purpose. The flag will lose some of its luster; the orders and missions may seem vague to you. That's okay. You know in your heart of hearts what you signed up for. The values of your squadmates can see you through. All the while, you may come face-to-face with an order that you don't agree with. If the order is just, you follow that order. You're a soldier. That's your job. But if the order is unethical, or

would compromise one of your values, it is your duty to take a step back. Pause. Do the right thing. Orders are damned if the integrity and selfless service of the United States military is up for grabs.

Chapter 2

Gravedigger

From Shovel to Rifle

"A man soon to become legend." This quote sits on the text box of the very first story starring Ulysses Hazard, better known to comic book fans as "Gravedigger." Personally, I think any man with a name like Ulysses Hazard is an instant legend. Ulysses is the name of one of the greatest adventurers of all time, who overcame several mythological obstacles in a journey to return to his family. A hazard is an agent that causes damage to humans. It is implicit in his name that Ulysses Hazard was going to defeat burdens and foes far beyond his fellow soldiers.

We meet Ulysses hunkered down with his squad, enduring bombardment from Nazi forces, clutching their pickaxes and shovels. The first thing any eagle-eyed reader should notice is that his squad is made up entirely of African American soldiers.

I forgot to mention the other important quote from Gravedigger's introductory caption box: "Just ask Ulysses Hazard, a man who had to fight not only the enemy—but his own country." This is an important distinction I'm going to examine throughout this chapter; at every turn, Ulysses is a comic book character told not to fight, and in every case, he does so anyway.

During World War II, segregation laws infiltrated every aspect of American society. In the American armed forces, African Americans who were drafted or volunteered were assigned to segregated units as cooks, quartermasters, and gravediggers— just like the unit that Ulysses Hazard is a part of.

Thankfully, my time in the Army was nothing like this. I didn't enjoy many privileges as an enlisted man, but as a Caucasian

soldier, I spotted the differences. One of my best friends in the service was an African American sergeant by the name of Linus Thuston. He was without a doubt one of the smartest men in my unit, and one of the coolest non-commissioned officers in charge of us. Linus understood what it took to lead men. He morphed many of his commands into concepts we could understand. Plus, he was always good for a laugh. If Linus was around, we would make fun of many of the base commanders. Without Linus, our unit would have been worse off. We needed Linus like the DC Comics Army units needed Ulysses Hazard.

Before his grave-digging days, Ulysses grew up in Birmingham, Alabama. As a young boy, he had to overcome polio, which left him half-crippled. He gritted his teeth and forced himself to overcome his illness, pushed himself to walk, run, and do "everything a normal person could do or die trying," as he says in his first appearance. Ulysses trained hard, working after hours, building up his strength and stamina to be the best soldier the US Army had ever seen. However, all of his accomplishments meant nothing. In the end, he still had to suffer the indignities of his time. As a result of his skin color, he was assigned to latrine duty.

Many other men would have folded in light of this setback, but not our hero Ulysses Hazard! He took his duties seriously. Ulysses endeavored to do every job so well that someone would take notice. After scrubbing toilets for years, he was promoted to sergeant and put in charge of a grave-digging detail. Ulysses remarked that he only hated the blind attitude behind his unfair treatment. Ulysses knew he was the best soldier out there—and soon he would get the chance to prove it.

In his first issue, deep in the European front of World War II, Ulysses and his unit heard the screams of a woman. Shells were

flying left and right, pinning his grave-digging unit down. Even though his group was supposed to be non-combatant, Ulysses flew toward the farmhouse, the source of the screams. Next, when one of his fellow soldiers bellowed, "Let the real soldiers do the work," Ulysses charged toward danger. He charged toward his destiny. In spite of the Army at the time classifying him as a gravedigger, at that moment, Ulysses was a real soldier. Then he launched himself through a window, shovel first, to take down several Nazi soldiers and save the woman. It is a powerful moment. A Black man with only a basic tool in hand was able to defeat soldiers of an empire dedicated to destroying anyone outside the scope of their perfect Aryan ideal.

He was a hero, certainly, but Ulysses did not achieve victory all by his lonesome. Behind his back, a luger was raised, ready to take the kill shot on the astounding Ulysses Hazard. Thankfully, Andy, a fellow gravedigger soldier, followed him into the farmhouse and walloped that Nazi with his own shovel. Andy saved Ulysses' life.

These two American heroes would get little chance to celebrate their victory, sadly. This was their first chance in the war to make a real difference and fight like real soldiers. No, their moment was interrupted by bigotry personified, their commanding officer, Lt. Gage. Gage strutted into the room, bellowed that the civilians must have saved themselves from the Nazis. He was utterly unwilling to listen to Andy, who attempted to correct Gage about who actually saved the day. Lt. Gage's feeble mind was incapable of accepting two Black men as heroes, so he put Andy and Ulysses on report.

In our current time, it can sometimes be very hard to read scenes like this—particularly for an old Army soldier, like myself. All of Lt. Gage's treatment of Ulysses violates the value of loyalty and

flies squarely in the face of Army values, which proclaim that you must stand up for your fellow man and fellow soldiers. The blind hatred and fear of Ulysses and his abilities is bewildering. Ulysses took the oath and he defended it. His honor is valid and true—just like every other soldier. Simply because of the color of his skin, Ulysses was pre-judged by the white men in the Army and found to be lacking.

In many cases, Ulysses is a better soldier than Captain America. In the previous chapter, I explained how Captain America was almost more of an ideal than a man. Ulysses, on the other hand, represents the man: a man's drive to push through and be accepted because he knows he is the equal, if not the better, of every other soldier in the Army. He believes he is the best, and he proves it by winning a battle with only a shovel. I'd like to see Lt. Gage try this same gambit. Gravedigger is the perfect representation of adversity versus privilege. As in every superhero's origin story, it's Ulysses' original obstacles that mold him into a powerful soldier.

His legend only grew when, during another mission, the grave-digging unit discovered another opportunity to stand up. A Nazi buzzard (plane) flew a sneak attack on their unit. In a split-second leap of heroics, Ulysses' pal Andy pushed their commanding officer, Lt. Gage (remember him?), out of harm's way. Simultaneously, Ulysses scooped up a bazooka and fired off an extremely difficult shot at the evading plane. If you remember, Ulysses had trained himself to be the best soldier. A shot that should have been difficult for a normal man was child's play to him. Of course, he made the shot and took down the Nazi plane. However, Ulysses discovered his fellow gravedigger, Andy, did not survive the attack. His fallen comrade's sacrifice, and the amazing one-in-a-million shot he had made, boosted Ulysses' confidence enough that he demanded the Army move him to

a combat unit. With his help and skills, the war would be over sooner, he boasted—and with a soldier as talented as Ulysses, this was no exaggeration.

His request was denied, of course, because the 1940s could not be as progressive as we would like to rewrite them to be. It's at this moment in his story that Ulysses takes another step toward his destiny as Gravedigger, the ultimate comics soldier.

He invades the Pentagon! I did not miswrite that sentence. Ulysses Hazard became so fed up with the bureaucratic and bigoted responses to his service that he decided to seize his destiny by the horns and force the bigwigs in the Pentagon to give him his due. Can you imagine the guts it would take to make this choice? You would have to be so convinced you were right that invading the headquarters of the most advanced and powerful military in human history would seem like a logical decision. Like the powerful heroes of myth and many superheroes before him, Ulysses proved that he was not going to wait for his destiny. He would take it by any means necessary.

In a move that could be considered patriotism or madness, Ulysses, like a bull in a china shop, fought through every level of security at the Pentagon. No one could stop him. He had a purpose. No man could stand in his way. Though my prose may make it seem like Ulysses carried out this act with the drive of a madman, his actual attack was far from uncontrolled. It was crafted with the intelligence of a smart Army commander. Throughout his assault, Ulysses had several opportunities to kill his fellow soldiers—and. in every instance, he did not. This was his intention. How could he convince the armed forces leaders that he was to be trusted to lead the fight in this war if he so casually assaulted his brothers in arms? The decision to respect and preserve the lives of his fellow soldiers would turn out to be the linchpin of his destiny.

Then Ulysses blasted through the door of the war council and came face-to-face with the Secretary of War! He threw a live grenade on the table in front of the secretary and asked, if he could do lethal damage to the security of the Pentagon, what might he be able to do to the enemies of the Pentagon? Needless to say, the Secretary of War was intrigued. He could imagine.

You may be asking yourself: Could something like this happen in real life? Could a human being who felt discriminated against as a result of their race, sex, or sexual orientation break into the Pentagon and force the Joint Chiefs of Staff to implement change by recruiting them into the current war based on a display of the havoc they caused? The answer is—unequivocally—no. That insane patriot would be locked up in the military prison at Fort Leavenworth faster than you could say "Hurrah." But this is not the real world we're examining; this is a comic book: a medium of determined men and women destined to seize opportunities in grand ways—ways that make us cheer them on.

Now, my struggles to join the Army were nowhere close to the hardships Ulysses had to endure, and I respect his character so much for never stopping, never giving up, and making it through, even if he had to make his desires happen with a grenade and a grand gesture. With the loud thud of an explosive device on a table, Ulysses changed his destiny. (It would not be responsible of me if, at this point in the book, I did not mention that grenades cannot solve problems. Sure, they may seem flashy and all the rage, but these small explosive devices do more harm than good. Grenades should not be used as problem-solving implements. Safety rant is now over.)

Fortunately, the Secretary of War was impressed by Ulysses' gambit, noting that, during his attack, he could have easily killed many of his fellow soldiers, but he did not. The secretary offered

Ulysses the position of a "doomsday commando": a man who can handle the dirty jobs, the impossible assignments, and gives him the codename "Gravedigger." Behind Gravedigger's back, however, the Secretary boasts: "With the tasks I have planned for our brash young sergeant, I don't think we'll have to worry about him very long."

The racial implications and trickery which accompany the very moment Ulysses Hazard finally gets what he wants are not something I am even remotely qualified to write about, and I understand that. Needless to say, this is another instance of the story proving my point that Ulysses is a *pure*, good soldier. All of his assumptions about the leaders in his military are right. Due to their racial bias, they will never see him as equal. They will never see him as a soldier, in spite of knowing he is their better in every way.

Gravedigger's first mission as a combat soldier led him back to France, and straight back to his old unit. Outside a small French village, Gravedigger's unit was pinned down by sniper fire. Through a feat of extraordinary gymnastics (a proud DC Comics tradition, especially when you consider Dick Grayson, the first Robin), Ulysses was able to leap up to the enemy's position through a physical feat he figured the Nazis would never dream of: leaping up over twenty feet to grab the ledge of an unguarded window by bouncing off walls and a tree! He sprang inside and made quick work of the enemy soldiers. Here the narrative stops for just a beat. The panel goes dark and the caption reads: "Gravedigger stands surveying the carnage he's just wrought, trying to convince himself that the blood-puddling corpses aren't men, but merely the enemy. He's almost successful."

This moment stands out to me. It's something all service members have to face during their careers, unless they're very

lucky. For all of Ulysses' bravado, his courage, and his pure gumption, he's still a man. He still has morals, and he still feels the loss. This is powerful. It takes him beyond a caricature of the most badass soldier of all time and makes him real. How do these things change you once you make the decision to act on them? Can you live with it? Can the greater good of protecting your squad and your mission overcome the future guilt? One panel in a comic book can feel like an eternity. So can this decision for all service members. The brief second the story pauses for speaks volumes. This is a quandary all service members might have to face during the course of their duty. Can you take another's life to save your own or the lives of your unit? Many times, when you are faced with that decision, you only have a second, a moment, to make a move that will change your life. Was this action good or bad? That's up to you to decide. If your life or your fellow service members' lives are in danger, you have to act. You have to do whatever it takes, within reason, to save lives. It was the move Ulysses made. Did it change him? Of course. It's impossible to take a life and move forward as if nothing happened. However, Ulysses is a true soldier. He progressed past his feelings temporarily.

Soon afterward, Gravedigger encounters a character that we all know and love: his old commanding officer, Lt. Gage! When Gage sees Ulysses, he tries to arrest him for impersonating an officer! The ups and downs of storytelling really are on display during this scene. Only in a fictional story could you go AWOL (absent without leave) and come back to your unit with a promotion. Ulysses left his unit as a sergeant to return as a captain. Now, he was Lt. Gage's commanding officer! How do you like them apples, Gage?

Several stories down the road, Gravedigger is traversing the Sahara on a very important mission and suffers an injury that

leaves him with a cross-shaped scar on the bridge of his nose. This physical feature and his bravery would be his defining features for the rest of the comic. In the final issue of *Men of War*, DC Comics decided to team up its two most famous war characters, Gravedigger and Sgt. Rock. (We'll get to the core of Rock in a future chapter.) These two famous comic book soldiers join forces to destroy an enemy artillery position. The mission was a grand success, not just because these two characters were good soldiers, but because DC Comics' readers would have rioted if these two had failed in their final issue. In the last panel, Gravedigger remembers his military roots and begins to bury the fallen members of Sgt. Rock's Easy Company.

Until recently, that was one of the final adventures of Ulysses Hazard. His post-World War II whereabouts remained a mystery until a mini-series called *DC Universe Legacies* (2010). In issue four of the series, called *Snapshot: Remembrance*, the readers are shown a reunion of DC Comics' war characters which takes place on July 4, 1976. One of the warriors in attendance is none other than Ulysses Hazard. The story reveals that he did survive the war and excelled in the Army to achieve the rank of general. He was now a valued leader in an army that originally didn't want him.

I can never know the struggles Ulysses Hazard faced in his military career, but I do know this: his bravery and will to never give up are to be admired. While sometimes he became a little overzealous (don't use grenades to illustrate your point, kids!), the fact of his successes and leadership of many men to safety says so much. Like many superheroes, there were many times Ulysses could have given up. But he didn't, he persevered, and he prospered. I would be proud to serve under a man such as the Gravedigger. He's a hero who stands on the same platform as Superman.

Chapter 3

Captain Marvel
Flying from Values

Carol Danvers may be one of many superheroes who punched evil in its stupid face under the moniker of Captain Marvel, but she is also one of the few female heroes to serve her country. Since her soft reboot in 2012, many comic fans have branded themselves with the symbol on her chest. Marching to the beat of a brand-new drum, these Marvel fans began to call themselves "The Carol Corps." Carol has been "all in" in every aspect of her life: from her military experience to her time with the Avengers to inspiring the aforementioned fans. Thinking about it, there's not a single comic book convention I've been to in the last five years where I haven't seen someone cosplaying the spectacular Captain Marvel. She dives into her life like an arrow flying at a target, so let's jump into her chapter with that same gusto.

The daughter of Joe Danvers, a former US Navy officer, Carol has always had one foot in the military world. She dreamed of being an astronaut, one eye always on the stars. Disappointingly, her father couldn't fathom why any daughter of his needed a college degree. Joe Danvers believed Carol's perfect place was in the kitchen as a housewife. However, that was not Carol's destiny. Was this belief spurred by his time in the Navy, or by his upbringing in the mid-twentieth century? My own parents have some fairly old-fashioned beliefs, but I don't think either of them believes a woman's place is in the kitchen. I think this may have been a time when the creators who developed Carol's origin didn't want to fully form Joe Danvers as a real character. Rather, they imagined him as an archetype or obstacle to Carol's destiny. So, basically, Joe Danvers was a woman-hating curmudgeon and nothing more.

In order to prove her father wrong, Carol sneaks off and joins the Air Force. As an airwoman, Carol soon becomes a pilot and adopts the call sign "Cheeseburger." This training will be a springboard to her ultimate goal—skyrocketing to other planets as a full-fledged member of NASA.

It's here that I must admit a kinship with Carol. As a small boy, I, too, wanted to join the awesome ranks of NASA, half-spurred by my constant viewing of *Star Trek: The Next Generation* and half by the wanderlust that ultimately drove me from my boyhood farm in Kansas. I was ever-present in this dream until my third-grade teacher—Mrs. Hazen—told me I'd soon have to develop an aptitude for math if I ever wanted to count myself among NASA's ranks. (Fun fact: to this day, I have the mathematical knowledge of a caveman.) This revelation scuttled my rocket-ship dreams faster than you could say "Pythagorean theorem." Since then, any time a fictional character seized their dream and gained the very exclusive rank of "astronaut," I've always stood up and applauded.

Carol threw herself at her dreams and her military career. Was this because she unconsciously emulated her military father? Studies have shown that a high percentage of military children form strong connections with the ideals of military bases, culture, and personnel. I would theorize that this happened to Carol. At the funeral of her father, when asked to say a few more words, Carol only says this about the man who raised her: "He was a worthy opponent."

What a perfect window into the soul of Captain Marvel this statement is. Even after his death, Carol still viewed her relationship with her father as a battle. At each turn in her life, Joe Danvers was her opponent. A father and daughter as enemies and not allies is quite sad when you consider it. Nonetheless,

it does illuminate how this superhero operates. Writer Kelly Sue DeConnick bestowed upon Carol Danvers a motto while she was penning the character. That motto is: "Higher, further, faster, more."

Another way to interpret that motto is "Never surrender, never give up"—a positive motto when applied to an airman or a soldier. I can almost hear them chanting it as the trainees run across the base for their morning's physical training.

Yet, the words "higher," "further," "faster," and "more" can lead a person away from humility. Why do these values matter to the story of Carol Danvers? Well, humility is one of the United States Air Force's core values. Each military branch has its own set of values that help service members get the mission done while inspiring them to the very best at all times. These values are integrity, courage, honesty, responsibility, accountability, justice, openness, self-respect, and humility. Airmen are taught to study them, follow them, and encourage others to do the same through their actions and words.

These would have been drilled into her head during her training, and the word "more" flies in the face of it all. (Yes, the pilot pun was intended.) This conflict between humility and fighting for "more" lies at the very core of Captain Marvel. It can illuminate the many times she has fallen and succeeded as a superhero and as an airwoman.

It wouldn't take Carol long to go from airwoman to cosmically-powered superwoman. She retired from the Air Force to take a position at NASA as head of security. This allowed her to leave the service a full colonel. (Take that, Captain America! She outranks you.) It was during her stint at NASA that Carol first encountered the man who would change her life, Mar-Vell. He was a soldier of the Kree, an interstellar empire that bowed down

to a giant talking head called the Supreme Intelligence. (No jokes there; sometimes superhero comic books get silly.) Carol was eventually kidnapped by another alien called Yon-Rogg. Mar-Vell attempted to rescue her and, during his battle with Yon-Rogg, Carol was exposed to the Kree Psyche-Magnitron. The Psyche-Magnitron's only purpose was to confer superhuman abilities to people! Of all the alien supermachines in all the galaxy Carol could have bumped into, she sure picked the right one! Although Carol was unaware of her new abilities at first, she would eventually don a costume and join the ranks of costumed vigilantes as Ms. Marvel—a tip of the hat to Captain Marvel, the alien hero who had rescued her.

Recently, the *Life of Captain Marvel* mini-series, written by Margaret Stohl, revealed that Carol's mother was actually a Kree alien. So, instead of the alien device giving her superpowers randomly, the origin has now been changed to the Psyche-Magnitron activating her latent Kree abilities. Overall, I predict this small change will do little to alter the arc of Carol Danvers stories going forward.

Another one of the United States Air Force's core values is justice: "Those who do similar things must get similar rewards or similar punishments."

It's this value that, I think, led Carol to seek out—and later join— the Avengers. This team of "Earth's Mightiest Heroes" gathered to fight the foes no single hero could withstand. Carol would be drawn to this team because it has a very militaristic culture. (She does outrank Captain America, remember?) The Avengers have a team leader who gives orders, they take votes on who can join, and they even have access to the government's criminal files. This core belief of justice in Carol's head, the one that probably

has been nagging her since her time in the Air Force, can finally be honored by joining a super team.

It takes years for Carol to adopt the moniker and rank of "Captain Marvel" officially. Maybe it is a sign of deference to Mar-Vell—a man she very much admired—or maybe she didn't want to be accused of being a superhero copycat. (Marvel isn't as fond of legacy characters as DC Comics is.) It wasn't until Steve Rogers insisted that Carol began to call herself by that designation in the field. All it took was a simple dare from an old Army soldier.

Writer Kelly Sue DeConnick threw Carol into a situation where she had to directly confront the nature of the military. Not content with giving Carol her promotion from Ms. Marvel to Captain Marvel, DeConnick wished to send Carol directly to war—World War II, that is. In *Captain Marvel Volume 7,* through a series of time-travel shenanigans, Carol finds herself in a hairy combat situation on a battlefield. She has no way out. Suddenly, she's rescued by the Women's Air Service Pilots Banshee Squad, Class of 1943!

First, I have to admit my bias. I generally do not enjoy stories about characters being lost or thrown into a time period other than their own. However, having Carol confront airwomen of the past is an intriguing turn in the plot. How will she react to their decisions? How will they react to hers? The possible issues are endless, as we see two generations of servicemembers from different times, with different points of view, confronting combat.

After spending some time with the Banshee Squad, Carol admits to the group that her problem-solving methods generally involve "blasting it, punching it, outrunning it, or throwing it into space"—meaning that she is an attack-first-and-ask-

questions-later type of woman. Interestingly enough, she directly contradicts this statement two issues later. In issue three of the DeConnick run, Carol and the Banshee Squad encounter a Japanese pilot in control of an advanced alien ship. Once he's defeated, she lets the pilot go back to his home base. The Banshee Squad chastises her: "How can you let him go?" Carol ignores her fellow combat women and demands the pilot put together the best squad made up of his fellow combatants. Then he is to come back to this very spot, so Carol and her all-woman squad can kick their asses.

Generally, it's not a smart move for anyone in the military to give up a tactical advantage. A captured enemy combatant can provide valuable intel, and said intelligence can save many lives in future battles. At first, this move can be seen as a gesture of "fair play." Carol wants to prove that she and her fellow warrior women are superior to any army the enemy can muster. Upon closer inspection, though, her actions can be seen as a direct contradiction to the Air Force's policy for military professionals to not display anger. Does Captain Marvel really need to prove herself against a World War II Japanese military squad? Yes, they have advanced weaponry, but Carol is one of the most powerful cosmic heroes in the entirety of the Marvel Universe. This woman has fought Thor and the Hulk and lived! It doesn't matter what technology this enemy unit has—Carol will decimate them. She knows it. Yet she issues the challenge and risks the lives of the Banshee Squad in the process. Luckily, the Banshee Squad makes it through the skirmish. However, things could have gone very wrong for Carol and her team. These actions call into question something at the core of Carol Danvers: just how good a leader is Captain Marvel?

When she left the service, she achieved the rank of full bird colonel in the Air Force. This proves she was no slouch. No one

can reach the rank of colonel in any military branch without being a great leader and a hard worker—unless a copious amount of bribes are issued in order to achieve said rank. This was not the case for Carol.

After the massive, cosmic comic book event known as *Secret Wars* (2015), Carol is offered command of the Alpha Flight Space Program. No, this was not your father's Alpha Flight. No sasquatches or men bathed in the visage of the Canadian flag are on this team; this organization manned the Alpha Flight Low-Orbit Space Station and set themselves up as the first line of defense for Planet Earth. It puts Carol in the unique position of taking charge of a brand-new team called "the Ultimates." This team became proactive, searching for scientific and non-violent solutions. One of their first missions was to cure the world-eater Galactus of his problem of eating worlds! (Somewhere, Galactus creator and late comic legend Stan Lee felt me write that sentence and a tinge of anger come over his spirit. "Undo my great work? Never!")

This Ultimates team operated like a military think tank, and it allowed Carol the opportunity to command and collaborate with scientists instead of soldiers. Suddenly, Carol is exposed to problem-solving which does not involve violence or punching your enemy into submission. Despite being exposed to new worlds and infant galaxies of thought (literally), Carol is soon confronted with another situation where her core beliefs will be called into question.

An Inhuman with the ability to see the future, named Ulysses Cain, becomes the focal point of the storyline *Civil War 2* (2016). Carol is intrigued by Ulysses and wants to use him to stop crimes and major disasters before they happen. One man is opposed to using this Inhuman and following his predictions without

question. That man is the Iron Man, Tony Stark. Tony figures that, if Carol can stop these crimes before they happen, then the visions can only be from a single possible future. Nothing guarantees these specific people will actually commit the crimes, simply because Ulysses says they will. Carol ignores Stark and acts on every premonition Ulysses makes. This leads to severe personal costs for Captain Marvel and those who come down on her side.

During an incident with the mad titan Thanos, the sensational She-Hulk is critically injured, and Carol's current lover, War Machine, is killed. Not long after this, Ulysses has a vision implicating Miles Morales, the Ultimate Spider-Man, in the future murder of Captain America. Carol wants Miles arrested on the spot. Tony Stark does everything in his power to prevent her from achieving her goal. A chaotic superhero battle erupts for the very soul of the Marvel Universe.

The fallout from this event leads to the death of Tony Stark (only for a few months. This is comics! No one stays dead forever, kids!). Carol Danvers is soon invited to the White House by the president, who rewards her with a blank check to do whatever she sees fit. It is a gift of thanks on the president's behalf because he admired how she handled the situation and appreciated knowing what was going to happen in the future.

Should Carol have been rewarded? Her actions in this event are definitely in the "ends justify the means" camp. Several times, throughout *Civil War 2*, Carol arrested innocent people merely because of the possibility they would commit a crime in the future. Should innocent people have to suffer for the greater good, or the greater future? Our journey to the ultimate goal is just as important as the final outcome, and our morals, and our actions to achieve that outcome, are equally as important. At

several points, Captain Marvel violates the Air Force's "Service Before Self" model. It states that one must respect others: "We must always act in the certain knowledge that all persons possess fundamental worth as human beings."

In *Civil War 2*, Carol saw innocent people as criminals. She locked up these citizens as criminals before any crime had been committed, and she treated said individuals as criminals. Is that respect for others? I would argue it is not. I would argue that Carol Danvers was a poor example of a moral airwoman during this storyline. (I could also fill up the pages of a whole other book questioning the motives of a fictional president who applauds her actions therein.)

The most profound thing that can be said about Carol Danvers is that she is layered. For every story in which the values of the armed forces shine through, there is another contrasting story where she fails them. I admire her bravery and her commitment, but sometimes her cosmic powers outrace her mind. Her leadership capability is beyond reproach. Her morals are where she falters. Yes, Carol is not the perfect ideal like Captain America of the first chapter, but as a full bird colonel, she is responsible for representing an example for the airmen in her command, for the heroes she leads, and for the civilians she saves. General Ronald Fogelman, who served as the fifteenth chief of the US Air Force, once said: "Because of what we do, our standards must be higher than those of society at large. The American public expects it of us and properly so. In the end, we earn the respect and trust of the American people because of the integrity we demonstrate."

Does Captain Marvel meet the standard that General Fogelman preached? All evidence points to no. She may be a hero and inspiration to millions, but Carol Danvers could definitely try to

do better. She has common values with other service members. If she allowed herself to follow them, then Captain Marvel would truly fly.

Chapter 4

War Machine
The Armored Battle Buddy

Everyone in the world knows the phrase "Batman and Robin." Sidekicks are usually underappreciated, just like the supporting casts in many comic book worlds. These supporting casts include characters who, at first glance, many would consider to be "sidekicks." In many stories, sidekicks are looked down upon as lesser heroes when measured against the deeds of their heroes/protagonists. However, these characters are the furthest thing from insignificant. These cast members stand by their heroes and support them in each of their battles while, at the same time, not following their orders blindly. Characters like Lois Lane in *Superman*, Wong in *Doctor Strange,* and James Rhodes in *Iron Man* stand taller than their heroes and—in many cases—outshine them in every aspect.

James "Rhodey" Rhodes first appeared in *Iron Man* #118 (1968). To Tony and the reader, he was simply a helicopter pilot. It wasn't until many issues later that we learned James' true origin story. He was not only a pilot, but an Air Force helicopter pilot. (In another instance of Marvel Comic retconning, Rhodey originally met Iron Man during the Vietnam War. Now, their rolling—and constantly updating—timeline has their fabled meeting happening during the Afghanistan conflict.)

When Tony came across Rhodey in the steamy jungle, the billionaire philanthropist was clad in the very first Iron Man suit he ever designed. (We'll not mention why Tony is also wearing a trench coat and hat on top of the armor. That subject could fill another three-hundred-page book.) Rhodey was desperately trying to fix his helicopter to get back in the air when the newly

minted "Iron Man" loudly lumbered through the trees. Rhodey did what any decently trained airman would do—he pointed his M16 at the monstrosity and fired! When the bullets had no effect on the Iron Man, Rhodey remarked, "Oh mama, looks like I've stepped in the bad stuff this time." Iron Man assured Rhodey he would not harm him, but he needed the batteries from Rhodey's downed helicopter to recharge his suit. If he couldn't get a boost soon, the suit would fail and Tony Stark's heart would stop. (This was during the time in Tony Stark's career when he still needed the Iron Man suit to survive.) The two men barely had a moment to consider their next moves when a Viet Cong patrol attacked their position. The two were forced to unite against a common enemy. There's no quicker way to forge a bond than that! Iron Man saved Rhodey's life, which ultimately convinced James Rhodes to allow Iron Man to drain his helicopter's batteries. As a result, the helicopter was permanently down for the count. Not only that, but Rhodey's leg had been injured during the surprise attack. Determined not to leave behind the brave soldier who had helped him, Iron Man carried Rhodey on foot until they reached the American perimeter and safety. After being released from the hospital, Tony Stark appeared to Rhodey and thanked him for helping his Iron Man reach safety; he then offered Rhodey a job after the hostilities in Vietnam ended.

(Readers' note: Iron Man kept his real identity secret from Rhodey and made him believe Iron Man was Tony's bodyguard. One can only imagine the conversations they must have had, jaunting through the jungle. "Hey, Iron Man, what movies do you like?" This was a ruse that Tony Stark perpetrated on several people in the comics over the years, not just Rhodey.)

This brief encounter proves Rhodey was ready to think outside the box. He wasn't—and is not—limited to the rules and standard procedures of the Air Force. Rhodey is willing to critically think

about the situation and use the available means to accomplish his goal. You don't look a gift iron robot man in the mouth. After a series of other jobs, Rhodey left the military and finally accepted Stark's offer. He became Tony's personal pilot and aviation engineer.

Many people like to put service members in a box—typecasting them, if you will. If you join the Air Force, then the only career fields for you after your service are flying jumbo jets for airlines, or NASA. Rhodey took a job that was a little of both. If not for his acceptance of the strange, he would never have found himself working for a multibillionaire superhero, a job which would eventually lead him to his own true destiny: becoming a superhero.

When my time in the service was over, I considered many jobs connected to my old life. I had just come back from a year in Iraq, and many of the civilian contractors who staff bases in the combat zone are always looking for experienced former soldiers. Since you've already seen the combat theatre up close, you know exactly what to expect. There would be no surprises. (In retrospect, I can't imagine any full civilian non-veteran who would accept a job in a combat zone. No job pays that well.)

There is one employer whose pay is woefully poor—the US armed forces. Join any of the branches and, unless you quickly move up the ranks to captain or major, you're going to find your paycheck lacking. Now, there are plenty of other benefits that sometimes make up the difference when you are serving, but not many. Our fighting men and women are severely underpaid for the job we expect them to do. Civilian contractors in a combat zone, on the other hand, are paid handsomely. I remember asking the civilian who managed our fuel base on Tallil Air Force Base (the post I was stationed at in Iraq) how much he made. He simply

laughed and said, "It'll make your head spin, kid." It's the only reason I ever considered going back to the dusty lands of the Middle East, because maybe, just maybe, the pay would make it worth my time. I obviously never made that choice, since I now sit here writing this book. However, this exact choice was made by James Rhodes, and I like to think his Stark paycheck was very handsome. It's a choice I think many combat veterans would have also made.

Rhodey is also a character who values loyalty. Perhaps it was his many years serving in the Air Force, perhaps Rhodey always had a loyal bent, but this trait has come to define his relationship to Tony Stark. While many people in the world do not trust Tony, Rhodey always sticks by him. This essentially makes Tony his civilian *battle buddy*. That's a term for when you are partnered to another soldier in combat; it's your duty to look out for each other and ensure you both make it through the mission unscathed—no matter what. I believe this is Rhodey's mechanism for coping with civilian life and the strangeness of working for (and later with) Tony Stark. Think about it: most days on the job at Stark Enterprises, the Living Laser or Spymaster will come crashing through your windows, then try to steal the newest technological invention built by your boss. Only by focusing on his loyalty to Tony, a person who gave him a shot—a friend who took a chance on him—can Rhodey deal with the insanity destined to occur in the same building as Iron Man's exploits.

Several years later, Tony had been prepping and grooming Rhodey to take over Stark Enterprises, Tony's billion-dollar company. Tony had suffered nerve damage from extensive use of the various Iron Man suits and kept it secret. So...Tony faked his death—because when you need to heal from nerve damage, it's best to fake your demise to all your friends and place yourself in suspended animation. Needless to say, Rhodey suddenly found

himself in charge. He had to take control of a giant company and protect its interests by suiting up in the new Iron Man suit, called the Variable Threat Response Battle Suit. Rhodey even took Tony's place in the West Coast Avengers! (This is the Avengers team that stops beach crimes while surfing near the Santa Monica Pier. A very different vibe from the regular Avengers team.) These are situations Rhodey did not want to be a part of. However, he took responsibility and succeeded because of his loyalty to his "dead" friend.

This is the crux of every decision Rhodey makes. How can he support his friend? How can he support his fellow service members? It's all through the act of giving to the other, giving to his best friend. Does this suggest there is a piece of Rhodey that will not be an airman? Yes, it does. It's so central to his core that without it, he wouldn't know what to do or how to act. This value is what Rhodey ingrained into himself over the course of his service. All service members change when we go through the gauntlet of serving our country. How much and how little depends on the person. For Rhodey, he holds tight to what he needs to survive. If someone were to betray him, it would not go well. It would lead to what many would call a "Bye, Felicia" scenario.

When Tony finally rejoined the land of the living, Rhodey quit Stark Enterprises. These two men, who were best friends, didn't talk for several years after this incident. Can we really blame Rhodey? Rhodey stepped into a world he wanted no part of. He's a pilot. He likes to make avionics soar over the wind, not sit in boardrooms and put together reports on profit margins. Rhodey did it for Tony. His battle buddy betrayed him on a very fundamental level. If you can't trust your battle buddy, your most loyal friend, then who can you trust?

Tony gave Rhodey the Variable Threat Response Battle Suit as compensation for his deception, saying the suit was always designed to be Rhodey's. Thus, Rhodey was finally on his own, a hero with no one to take orders from. He renamed the shiny silver-and-black armor "War Machine" and even rejoined his old beach team, the West Coast Avengers. Yet this move did not last long, since Rhodey got into an argument with Iron Man (Tony) at an Avengers team meeting which led him to leave the Avengers altogether. The wounds of Stark's betrayal had not healed.

It's not hard to empathize with Rhodey in this instance. Loyalty is his defining characteristic. His whole character, in every story he appears in, is about helping out Tony Stark. When it is robbed from Rhodey, what can he do? Luckily, James wasn't sitting on his hands the entire time he was a supporting character. He was subconsciously observing how a superhero works and figuring out ways to do it better.

In fact, the War Machine armor is the perfect tool for James Rhodes. While the previous Iron Man suits had been designed for single battles and criminals, this is the first armor that was specifically designed for war. This is even the first armor in Iron Man history to include a giant Gatling gun on the shoulder! Repulsor beams aren't good enough for War Machine! He needs a gun that makes every criminal wet themselves in fear when they see the bullet capacity. This is a suit built for a service member, not a billionaire.

After years and years of fighting supervillains as War Machine, James Rhodes finally found a job that made sense for his time as a superhero and his time in the service. He was hired by O*N*E (Office of National Emergency) to serve as the direct command officer and combat instructor for the Sentinel Squad O*N*E program. If you've ever read an X-Men comic, then

you probably know what a Sentinel is. It's a big purple robot whose programming is to hunt, capture, and sometimes murder humans. Now, before you go on a rampage, Rhodey was not hired to kill mutants (mutants, of course, being the humans born with powers in the Marvel Universe).

(Side point: One could write a whole book about the bigotry of the Marvel Universe. Why do they fear Kitty Pryde when Spider-Man lives in the same city? There's no way to tell them apart, but I digress.)

The mutant killing machines were reprogrammed and repurposed to protect and serve the United States after the recent drop in mutant population, caused by the Marvel Comics event *House of M*. Not only was this a brilliant writing move on the part of Marvel Comics, but it was the perfect fit for Rhodey. After years of being a more gunned-up version of Iron Man on his own, Rhodey could rejoin the fold. This program could accomplish the same amount of good Iron Man could, but it folded into the rules and regulations of the military and the government. Plus, Rhodey gets to be at the top of the chain of command. For a man who had to put up with all the insane nonsense Tony Stark subjected him to, Rhodey would be looking for any semblance of structure.

Many veterans, when they leave their units, are excited to join the civilian world. The freedom of choice in all matters of your life is very appealing. Some find they dislike the lack of structure outside the military. This leads them to rejoin their former service branch.

James Rhodes found himself in a perfect position to make use of his expertise. Not only did he have prior service in the military, but no one in the world knew as much about cybernetics, mech tech, and being cramped inside a claustrophobic metal suit as him. From right out of the gate, Rhodey made his unit inclusive—

even allowing mutants to serve inside the Sentinel mechs. The team aspect was the primary goal. "Every last member of your team is your brother," Rhodey announced to his teams.

In a training exercise with his Sentinel Squad, another recruit freaked out when she saw the amount of firepower being levied at the team. Scores of tanks and planes were bombarding one of Rhodey's Sentinels. Smoke and ash filled the air. At the end of the fight, it was not clear whether the Sentinel recruit had won or lost. Suddenly, three Sentinels stood in victory as Rhodey boasted to the recruit, "It was never about taking down a single Sentinel, but taking down a Sentinel team."

The writer of the Sentinel Squad One series, John Layman, impressed me. In this story, we see Rhodey building an entire military unit out of loyalty. The fact that Rhodey holds fast to that idea is powerful. It makes him a good man and a good leader.

Finally, there is one more recent concept that affects not only James Rhodes, but many service members across the world: through various—and slightly more dramatic—storylines, Rhodey was killed while in a fight with the mad titan Thanos. (Remember him from *Infinity War*?) Many months after his death, Rhodey was brought back to life in the same procedure which also brought his good friend and old boss, Tony Stark, back to life. (Remember what I told you earlier about the impermanence of death in comic books?) In *Tony Stark, Iron Man* #2 (2018), days after rejoining the land of the living, Rhodey experienced a nightmare full of references to classic issues of *Iron Man*. He saw himself burning up in the atmosphere when he stood in for Tony in the Iron Man armor. He saw himself becoming a half-cyborg from a *War Machine* series that, very honestly, is better forgotten. Next, he saw the fatal blast from Thanos's hand that

had torn him apart, and he shot up in bed, covered in sweat, and screamed: "I can't stop dying in the damn suit!" This, my friends, is a classic example of a character struggling with PTSD, better known as post-traumatic stress disorder.

PTSD is a mental disease that develops after a person suffers a traumatic event. It is a malady which has become more prevalent in recent years, due to the number of War on Terror veterans returning from combat with it. It's a disorder that is being seen more and more in media, and it makes complete sense for a superhero to struggle with it—especially a military superhero. Think about the cataclysms and cosmic disasters these people face on a daily basis. If one of the elder beings of the universe shows up in your backyard and tries to eat your home planet, I think you will probably experience some trauma. Re-experiencing trauma through recollections of the event or flashbacks is one of the symptoms of PTSD.

Rhodey does the absolute wrong thing and suits up in the War Machine armor as soon as he can. Instead of seeking professional help, Rhodey puts himself back into the same dangerous situations that gave him PTSD. Remember, James Rhodes is all about loyalty. When his friend, Tony Stark, asks for his help, Rhodey is there. From the very beginning, Rhodey can't stand being inside the suit, and, once their superpowered fight with a bunch of villains begins, Rhodey starts to freak out. He quickly ejects from his suit, which gives Tony pause. He has never seen his strong support, his military hero friend, like this.

However, Rhodey didn't leave his best friend hanging for long. He crawled inside this mobilized battle vehicle named The Manticore. It has a steering wheel and feels like a flying armored tank. Rhodey warmed to it quickly. It made him feel like a pilot again. It's a brilliant move to connect the character all the way

back to the origin story where readers were first introduced to him. The heroes saved the day with all speed and on their ride home, Tony asked Rhodey what had happened to him. What was he struggling with? What was going on? "I can't be in suits anymore," Rhodey explained, "they're like coffins to me." Not only does his word choice evoke death, something Rhodey had recently experienced, but it doubles down on Rhodey's PTSD. Rhodey wanted nothing to do with his War Machine suit, and in the middle of a combat situation, he abandoned it.

I can sympathize with Rhodey. While I didn't suffer death at the hands of a giant purple Marvel villain, I did spend almost a year in a combat zone. From January 2005 to December 2005, I was stationed in Iraq. Something that many civilians might not realize is that, for every second you are in a combat zone, you are required to carry your weapon, usually an M16. This weapon becomes your second arm. Many people today would equate that feeling to their cell phone. The second it goes missing, it drives you mad. Not only does this weapon become a part of your life, but every decision you make is ordained by a standard set of rules. You may not drive off base without an armed convoy. If you do drive off base, your Kevlar helmet and flak jacket must be on at all times. Your weapon must be locked and loaded. All of these standard procedures add up and change your daily life in subtle ways. Think about completing these actions time and time again, day after day.

When I returned home, I no longer had my weapon. I could drive my car down the street to wherever I wanted. I can clearly remember once, in early 2006, freaking out over the freedom of being able to drive to Subway (this is by no means a chapter sponsored by Subway). The freedom of choices and the loss of those standard daily routines was frightening, and frankly, overwhelming. It took several months for me to feel comfortable

with being a normal "civilian" again. Admittedly, my thoughts and feelings took me nowhere near the severity of Rhodey's condition, but since his thoughts lined up with mine, I felt a kinship with his problems.

James "Rhodey" Rhodes is not only a great man, but he's an astounding character. In fact, he was my introduction to the character of Iron Man. When I first bought comics featuring the armored Avenger, Rhodey was the star. So I have a bit of a soft spot for him. Whether the writing choice was conscious or not, baking the character trait of "loyalty" into every aspect of Rhodey's life not only cements him as a hero, but also deeply connects to his military career. When I started the research for this chapter, I didn't expect to discover more about Rhodey. For years, he's always been Iron Man in the black-and-white armor. The not-as-cool Iron Man who was in the military. However, writing this chapter has changed my mind! I respect him as an airman, I respect him as a character, and I respect him as a hero. We could ask for no better example of a military hero in comic books. When used correctly, as in a character like Rhodey, the traits of the military can strengthen and enhance dramatic storytelling. His loyalty to Tony is not a weakness, but a defining trait that should be celebrated. In fact, Tony Stark said it best. When talking about Rhodey, he once said, "You literally catch me when I fall. You're James Rhodes. That's what you do." If we could all have a battle buddy like Rhodey, all of our lives would be better.

Chapter 5

Green Lantern (John Stewart)

The Hero of Change

When you say the name "Green Lantern," what character do you see? Before 1959, many people saw a blonde and barrel-chested dynamo by the name of Alan Scott. After that, and still to the present day, most people would probably say "Hal Jordan!" If you were a comics fan who grew up in the 1990s, you might say "Kyle Rayner." Some might argue for G'Nort, the silly dog creature Green Lantern from Sector 68 (I'm lying. No one wants to remember G'Nort). However, after 2001, many children would immediately think of John Stewart, the Green Lantern of the *Justice League* animated series. His emerald constructs (mostly bubbles) and stern attitude were displayed to millions of viewers each and every week.

But who is John Stewart? How would you describe him? He's more than simply Hal Jordan's partner. He's more than a cartoon character. He's a Green Lantern of change. I'm not just referring to his skin color, either. Sure, he's the first Green Lantern main character who was African American, but John Stewart is not simply a character defined by his ethnicity. He's defined by change.

When he was first introduced in comics, John was an architect. His occupation was later changed to marine. With the retcon in place, John went from one military organization to another, trading the Marine Corps for the intergalactic policing of the Green Lantern Corps. He later went from sidekick to leader. During his first adventure, John is Hal Jordan (the main Green

Lantern)'s sidekick, basically a trainee. Eventually, John Stewart ascends the ranks and leads the Green Lantern Corps and its thousands of members from across the galaxy.

Could this be attributed to a military attitude from his time in the marines? Switching from base to base and mission to mission is common for anyone in the armed forces. Are service members like John at ease with that? I doubt it. Especially since John's military service was a change to his already established character history. John went from authority-questioning architect to order-following, rule-abiding Green Lantern pretty quickly. When he was introduced, he yelled at Hal Jordan constantly. When he was transformed into a marine, he yelled orders at Hal instead. In many ways, this shift turned his entire character into the stereotype of a "good soldier." (I mean no offense with that statement, Marines!) A character steeped in the rules and methods of a service member. It's now John Stewart's defining character trait.

To determine the breaking point, let's go back to John's original comics origin. His first appearance was in *Green Lantern #87* in 1971. One thing I can tell you about the year of 1971? All the racial biases and problems of the world had not been solved. Oh, what a peaceful time it must have been. (That last sentence was brought to you by the Sarcasm Department of America. You're welcome.) The color of John's skin became a basis of the plot from the beginning. It seems like it was an impossible task for DC Comics to introduce a non-white character and not address it. John immediately comments on the issues of the time and even forces Hal Jordan to reveal some troubling prejudices. For example, John first appears in a scene where he is defending two innocent men from two city cops. These policemen are trying to stop two African American gentlemen from playing dominoes (which, in my estimation, is the most innocent of street games.

Lay off, fuzz!). John Stewart comes to their defense and, with some razor-sharp words, convinces these two officers to move along. Hal Jordan witnesses the event from high above. See, Jordan had recently been informed by the Guardians of the Universe (the blue smurf presidents of the Green Lantern Corps) that John Stewart was to be inducted into their ranks. Jordan rebuffs this order at first. He claims John has too big a chip on his shoulder to be a successful Green Lantern. The Guardian ignores Hal's opinions and demands that he move past his petty bigotries. (I can assure you, I guffawed quite loudly when I read this panel during my research.)

Hal's viewpoint is quite antiquated by a modern standard. The scene he witnessed with John and the police officers was a prime example of the protection of the innocent. Since the Green Lantern Corps are basically "space cops," Jordan ought to have been praising John's actions. I do not wish to start throwing shade at Hal Jordan, who will be mentioned later in this book, but c'mon, man! Pull your intergalactic and possibly bigoted head out of your space ass.

The comic continues with Hal Jordan recruiting John Stewart in a diner. Hal simply asks John to join. John agrees to this proposition quickly, because he's unemployed at the time and has nothing better to do. (That last sentence was not a joke.) John's first change to the corps is his refusal to wear a mask. "I've got nothing to hide!" he exclaims as he throws the outdated green mask to the ground. Up to this point, most of the Green Lanterns that had been seen in comics had worn masks to protect their identities and families. It had become a standard trope of superhero stories, and here was John Stewart already pushing boundaries and changing things. Later in his debut issue, Jordan and Stewart came to blows over their crime-fighting philosophies. After a gunfight, Hal got heated when

John didn't simply stop it. However, John had realized the whole attack was a charade. The gunmen were firing blanks, and the crime was a setup to help a politician's career. Hal Jordan, by simply playing the hero, missed this fact, but John spotted it. In his very first mission as a Green Lantern, John adjusts the way Hal Jordan operates and observes crimes. John Stewart, in the comic books, is a man who is willing to bend the rules if it gets the right result. The moral result is always the best result.

Cut to the year 2002, the episode *Metamorphosis* of the *Justice League* animated series airs. John Stewart is a main cast member and the only Green Lantern on the team. While he investigates an incident with a train, his old friend Rex Mason hails him. How does John know Rex? From their time serving together in the United States Marine Corps. An entire comic book fandom's jaw drops, and a character's history is retconned. Much like this chapter, it took a long time for DC Comics to connect John Stewart to the marines, but now that it's happened, his history can never go back.

John Stewart, in the animated series, is a marine through and through. A professional marine with the most powerful weapon in the universe on the fourth finger of his left hand. He's much more serious about his role as one of Earth's protectors than he ever was up to that point in the comics. Whereas, on panel, he would challenge authority, the animated John Stewart follows orders and executes objectives—a man of duty. The question to ask is: why would the producers of the animated series choose to change John's character in this way? Well, when you examine the lineup of the *Justice League* cartoon, it becomes very obvious.

The animated *Justice League* team is made up of a bunch of rule-breaking outsiders. Don't believe me? Let's break it down: their leader is Superman, the most powerful being on Earth,

who only owes allegiance to hope and innocents. Batman is a rule-breaker and Wonder Woman is a mythical being who does whatever it takes to win. Martian Manhunter routinely invades minds without permission. Flash is the rookie of the team and wouldn't know the meaning of a rulebook if it bought him dinner. This leaves us with Hawkgirl. She's a secret member of an intergalactic army invasion force. Not only does it make sense that John would have a relationship with her, but it also immediately gives him a character who will back his every action. She is a fellow soldier. This animated team is rudderless. Superman should be the leader, but he's too nice to give orders. Changing John Stewart's background to a marine immediately creates an understanding with the audience, specifically the children who were the show's primary audience. John will always do what's right, he'll fight harder than anyone else on the team, and he believes every mission should be about order. He's a no-frills marine. Get the job done is his attitude. In the cartoon, they even give John Stewart the "jarhead" haircut! This change allows John to give this team of superpowered outsiders a tactical advantage with his knowledge, thereby allowing the team to develop a sense of camaraderie by the end of the first season. The dynamic the show enjoyed was due to John's approach to decision-making and his new marine background.

While many see this change as a cliché, I think it vastly improves the character of John Stewart. I think the staler cliché would be to simply park John Stewart as an African American character who will do anything to challenge authority. There are several other characters in comics that fill that role much better: Luke Cage and Black Lightning, to name two. Giving John the strength of marine service immediately makes him a more singular character—especially when you compare him to the man who initially voiced concerns against his service, Hal Jordan. Hal is also a member of the military, US Air Force, but instead of

being a great example of responsibility, Hal is anything but. No character in the DC Universe would ever expect Hal to water their plants when they're out of town in the Vega System. John Stewart, meanwhile, can water your Ficus plant like no one's business. His military experience makes him a better leader than this Air Force flyboy. It makes John a perfect yin to Hal's yang. (Think clean thoughts, chum.)

This yin and yang relationship is a perfect metaphor for military service in all branches. Throughout my professional life, I have encountered fellow veterans like myself. We all don't stay in vocations that are similar to our military vocations. I've known TV writers, YouTubers, painters, and building repairmen, all of whom were veterans. All walks of life enter the service and leave the service with different ideas of what they want to accomplish, having completed their duty. It's a situation I encounter often. When people find out I used to be in the Army, it dominates the entire conversation, almost an insufferable amount. Their every question probes me about my life in the service, my time in Iraq. Also, the questions go from simple to ludicrous as their minds try to put together the puzzle that is my life. Here are some examples of questions I've actually been asked: "Why did you join?" "Were you ever tricked into doing something against your will?" "Have you ever killed anyone?"

It's the last question that bugs me the most. Here's a tip: Anyone who would ever answer that question in casual conversation is obviously lying.

I shouldn't be offended by these questions. People are just trying to learn more about me, but as we all know, human beings are multifaceted. No one part of our life defines us. Not our work experience, not our education, and especially not our skin color—which brings us back to John Stewart.

John Stewart's military background took several years to be applied to his comic book incarnation. *Green Lantern* #26 (2008) is the first comic mention of his marine history. John was struggling to reform the planet Xanshi using only his willpower. As he worked on the impossible task, the caption box read: "When I was in the marines, they used to say that pain is weakness leaving the body."

It's interesting to note that the civilian architect John might have cried in this scene. He would have yelled, cried, or emoted on some level. This new Marine John would not. Instead, he adds further fuel to the willpower-based nature of his Green Lantern abilities. His new methods and beliefs as a marine now make his weapon more powerful. He can focus his pain. He can focus his sadness straight into the ring. This is the start of the comic books doing a better job with his origin as a marine than the animated series did.

Shortly after the scene in *Green Lantern* #26, it was finally revealed what John's job in the marines was. He was a sniper. During the Sinestro Corps War event, Bedovian, an alien sniper, was expertly picking off members of the Green Lantern Corps. The Sinestro Corps was a military organization founded by Sinestro—former Green Lantern, and Hal Jordan's mentor—who built an army on spreading fear in the galaxy, and Bedovian was an excellent instrument of that fear. One by one, Bedovian killed the emerald soldiers until, in his scope, he saw another warrior looking back at him. Who was it? John Stewart with a shining green sniper rifle looked back at this evil madman and finished him. It remains a defining moment of the event. It's also a defining character trait for John Stewart because it completely contradicts his first origin. You have to be a very dedicated person to make it through marine sniper scout training. It's not simply a job in the military; it's a way of life. To complete the

training, a marine must be completely dedicated, organized, and focused. One of the main skills sniper school teaches is the ability to stalk. Can one sneak up on an opponent and not be discovered? A final task to complete the marine sniper scout training is to be able to take two shots on a seasoned sniper instructor. This means students must find and identify the target, secure and move into a sniper position without being seen, and fire on the instructor. These instructors are seasoned pros. They can spot anyone encroaching on their position within seconds. A perfect score is the only way to graduate from this school. You cannot be spotted.

This training teaches you to be independent. Out there, it's just you with your weapon, alone in the wilderness. You have to complete the mission or else you fail. There are no other outcomes. It teaches a marine patience and fortitude to get past all the small blunders that could be detrimental to the success of the mission. This means John Stewart would be a very focused man—a man who could hone in on the end goal, rather than the mistakes of his fellow Lanterns. He can be a part of the whole team, or be a singular man on a mission. He's adaptable.

It took until the gigantic DC Universe crossover *Blackest Night* in 2009 for readers to see a flashback to John's time in the marines. In *Green Lantern #49* (2010), John Stewart discovered the planet Xanshi, alive and well. Xanshi was the site of John's greatest failure. Many years ago, he was unable to prevent a bomb in the planet's core from obliterating Xanshi, but in the present day, Xanshi was somehow alive! John discovered that the Black Lanterns had resurrected the alien world. The Black Lanterns, a group of dead aliens resurrected and given power rings like the Green Lanterns, have the ability to resurrect planets as well as people. They also have the ability to get into anyone's mind. These Black Lanterns surrounded John as he armored up in emerald fatigues. Suddenly, the Black

Lanterns accessed his mind, and forced John to relive one of his worst memories.

The readers were transported with John to a war zone in an unknown country. It could be Afghanistan or Somalia, but it has never been revealed. We see John Stewart in his marine utility uniform. In front of him were two downed Blackhawk helicopters. Inside one of them was a friend of John's. Even though he tried to make his way there to rescue the pilot, John was ultimately too late. The mob of insurgents had beaten the pilot and killed his friend. This tragedy set John off. He began firing into the mob and taking people out left and right, letting his anger get the best of him. The Black Lanterns in control of this memory posed a simple question: would John have killed everyone in this mob? John shrugged the suggestion off, the same way he had in the memory. He grabbed the body of his friend and decided to take it home for proper burial, to have no man left behind.

When John emerged from the memory, he knew the answer to their question. His weakness gnawed at him. He would have killed everyone in that mob, if given the chance for vengeance. It was a weakness and he knew it. However, he's also a marine. There's always a new mission. There's always a new hill to climb, and he didn't have time for this. With a blast of bright energy from his ring, John tore away from the Black Lanterns' grasp, 'cause it's always time for him to move on.

"Moving on" is a powerful credo to give a fictional character who is also a service member. While in the service, you can't become attached to anything beyond your fellow brothers- and sisters-in-arms. You never know where you will hang your hat next, or where your next hot meal will be. All you can count on is the man or woman beside you. They'll be there. You can count on that. It's as solid as the Earth, and no force in the universe can break

it. If your character believes the same, they will hold fast to their convictions and fight through it all, no matter what. This is a great trait to reveal to your reader.

One minor gripe about the *Blackest Night* sequence, if I may. In the captions, John says of himself: "I'm a soldier with a chip on my shoulder." This is incorrect. Marines are defined by their mission, their training, and their history. They are marines, not soldiers. The Navy has sailors, the Air Force has airmen, and the Army has soldiers. Marines are always called "marines," and John Stewart would know that. I can only knock the editors and writer of this story for missing this simple, but insulting, detail to marines.

Change is something I've mentioned several times in this chapter, so it's fitting that the last John Stewart story I write about for you heralds the biggest change the Green Lantern Corps has ever gone through. For a brief period, the Green Lantern Corps was transported to the far reaches of the universe—billions of miles away from the sectors they normally patrolled. When the Green Lantern Corps finally returned, John stepped up and became the new corps leader. These Lanterns found a universe radically different than the one they had known. Their mortal enemies, the Sinestro Corps, had taken over their job protecting the universe, though they were creating order through fear, the emotion that drives every decision of Sinestro's army. John Stewart learned not every Sinestro Corps member was dedicated to Sinestro's fear-mongering, and some wanted to keep protecting the universe, just like the Green Lantern Corps, except they wanted to keep their yellow rings. Knowing this, John came up with an idea. The two corps would merge, solving both their problems. Adding the Sinestro Corps to their ranks would make up for all the Green Lanterns who were lost on the other side of the universe, and the Sinestro Corps would

gain a home. John soon allowed the Yellow Lanterns to install a power battery (the engine that fuels their rings) on Mogo (the sentient home-world base of the Green Lantern Corps). Initially, Hal Jordan opposed this idea, but John convinced him to come around. Teaming up a Yellow Lantern and a Green Lantern in every sector allowed the Green Lanterns to rein in the Yellow Lanterns and ensure that they could do some good in the galaxy. He united two corps and changed the dynamic of protection across the universe.

John Stewart reconstructs his line of thinking. No other Green Lantern would have come up with this idea. It's too radical, they would all say. How could we ever team up with our mortal enemies? John saw a better way. Why keep attacking the enemy when we can make them a part of our team? This compromise informs the next fifty issues and five years of *Green Lantern* stories. It's something you must admire about John. He uses the enemy's call for aid to become a sign of strength for the Green Lantern Corps.

John is a character of revolution—and revolution is not a term that many would relate to the military. Perhaps it is because his character was a free-thinking architect for more of the character's history than he was a marine, or perhaps it is because the simple fact of being the first African American Green Lantern was revolutionary at the time. John shows us that fictional military characters cannot be limited. He can adjust. He can change, and he can succeed by adapting. John Stewart is a great example of a military hero. The ideals of the marines do inform his positions and make him a stronger character for it. His history change has helped his character grow in ways I don't think would have been possible if he had simply stayed an architect all these years. John Stewart is proof that modification can be a good thing, in fiction and in life.

Chapter 6

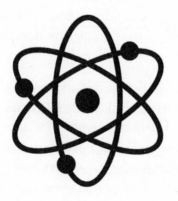

Captain Atom

Lost Time

There have been several characters named Captain Atom in comics. From the "Golden Age" of Comics to his reinterpretation as Doctor Manhattan in Watchmen in 1986, the idea of a normal human being turned into a god has endured in the sequential art medium. What is it about this idea that so fascinates us? Is it that we all dream of having unlimited powers, or is it the idea that no one can understand or relate to us once we change like that? While there have been many heroes who go by the moniker "Captain Atom," only one version of this character was intrinsically tied to the military: the Captain Atom introduced in 1987.

In Captain Atom #1, we were introduced to Nathaniel Christopher Adam in the 1960s. He was tied to a chair in an odd metal room and, over the course of the issue, we learn how he got there. He was a United States Air Force officer who had been framed for a crime he did not commit. To avoid execution, Nate agreed to participate in a secret government experiment under the watch of Col. Wade Eiling. This undertaking granted Nate little chance of survival, but it did ensure him a presidential pardon if he survived. The opening pages of his debut issue featured Nate telling a series of jokes as he faced death, performing a story about a man who was suing his wife for divorce while he pled with Eiling to keep his promise and deliver a letter to Nate's wife.

What is it about the connection between the military and the story's need for characters to volunteer for extreme experiments for the greater good? Our armed forces in the United States

ended the draft for soldiers in 1973, and ever since then, our fighting force has been a volunteer army. I volunteered for the US Army myself. Nevertheless, several stories about service members volunteering exist, going all the way back to Captain America's very first issue, as I mentioned way back in Chapter 1! Is it the drive to serve? The motivation to benefit humanity as a whole? While I see several connections between soldiers and this motivation, this plot device seems to be a shorthand many writers want to employ in their American-grown myths. If we prove our characters are brave enough for armed service, then they are certainly brave enough to be plugged into the Gizmacular 2000 Mackatron Device! (Patent pending by scientist Jason Inman.) It's certainly a trope I would like to see leave fiction. Armed service members are brave, I do not deny that. Still, they're not the only ones dumb enough to be poked and prodded by scientists. Many humans out there are willing to do crazier things for way less reward or less noble motivations.

Back in the story, Nate's experiment went off! The room filled with energy and revealed that Nathaniel had disappeared. Little did Nate know that he was being signed up for an experiment even more out-of-this-world and ludicrous—even by comic book standards. His experiment was designed to test the strength of an alien ship's hull. Of course, the only way to test something like that back in the 1960s? Detonate a nuclear bomb under it while a live human being sits inside and see if he survives! Nathaniel Christopher Adam was this human, and it appeared to the observing scientists and airmen that Nate did not survive the force of the blast. The shielding must not have been so effective after all. Thankfully, Nate exists in a comic book. This would not be his last adventure.

After the experiment, a form was observed on the air base. It spooked a plane that was coming in to land, and scared some

guards. It wasn't much more than a jumble of body parts and flesh that stalked across the airbase. It glowed and moaned as several airmen tried to subdue it. Once they had captured the form and trapped it inside a room, its flesh began to change. It molded into a shiny silvery skin, like the glossy metal you might see on the side of overpriced hubcaps, and at last, it finally appeared human.

The military personnel and scientists first hypothesized it may have been an alien life form merely mimicking human form, only, right then, General Eiling came on the scene and had a revelation while everyone else stood around telling jokes. Eiling dismissed the men because he recognized the form as a silver version of Nathaniel Christopher Adam, the very man everyone thought had not survived the experiment he'd volunteered for. Nate noticed the general and was confused—when did the colonel he knew become a general? Then the general dropped a knowledge bomb on Nate, poised to destroy his entire world. From Nate's perspective it had only been a day since the experiment, but, for Eiling and the rest of the world, twenty years had passed!

Being detached from the movement of time is a common theme in many soldier stories. Think of the most famous comic soldier of all time, Captain America! Steve Rogers' whole story hinges on being removed from his natural world in the 1940s and forced to reckon with the advancements of today. At the beginning of their origins, these two captains are very analogous. Captain Atom similarly loses twenty years of a life with his family. Nate finds out that General Eiling became the second husband to his now-deceased wife and his daughter has grown up. Consider the implications of that aspect. Every elder family member Adam knew is probably deceased now. The friends he had when he was alive would have thought him dead for over twenty years.

Every connection he would have had to the world is long gone. It's a frightening prospect. We all seek those touchstones in every aspect of our lives, and losing them all in one fell swoop would be rough.

It is similar to the feeling faced by every soldier who gets deployed. Whether the writers of Captain Atom made this choice intentionally or not, it is a perfect representation of an important aspect of military life. I have even experienced this myself. When you find yourself on deployment, it's hard not to think that the entire world is moving on without you, and, in truth, the world is moving on. You find yourself stuck in one location, performing the same missions day after day, and it soon feels like you are stuck in time. It becomes a trap you think you will never escape from. This eternal sad truth soon reveals itself as you lose fellow soldiers. Some people never escape that feeling. What will it be like once I can return to my life? Will I be able to return to my job and fit in like before? Will my significant other or girlfriend still love me? Will hamburgers still taste the same? (Answer: They taste better now.) Everything could have changed, but, since you are in the service, you have not been allowed to.

I have a vivid memory of this feeling washing over me. I can remember mounting up on the M2 .50-caliber gun on top of a Humvee at the back of a convoy in Iraq. Most convoys in the country would be escorted by three gun trucks: one at the front, one in the middle, and one at the very end to protect the rear. We were driving south from a forward operating base called Scania and the sun began to set. Orange and purple painted the sky behind the convoy, and, as the wind whipped past the back of my head, my mind began to wander. This often happens when you are on protection/guard duty on many missions in the military.

I began to take in the sky, and—I'm not kidding you—time froze. For what seemed like forever, I was stuck in this bubble inside my head, enraptured by this beautiful sky and confronted with the thought: "This is it." Life has passed you by. Family has passed you by. You will never leave here. Take in the sky. Breathe in the sky. The sky is all there is.

I don't know why that specific memory haunts me to this day. Maybe it was the first time I realized that, during my deployment, it seemed like I could never leave the war-torn country of Iraq. There was no escape from it, and I needed to accept that. Perhaps that was the first time I realized that no one, ever, will understand this experience except for me. Fellow service members might, but everyone back home, my friends and family, no matter how I try, can never fathom the experience. I feel that Captain Atom understands that feeling perfectly.

Before he even got a chance to try to come to grips with living in a completely new time period, Nate was betrayed by his government. The troops of the base knocked him out using sleep gas before locking him inside a titanium rocket. Nate only woke up once the rocket was several miles above the Earth's surface. With his new powers, he peeled back the titanium skin like butter and discovered one of the small joys of his new situation: superpowers! Nate smiled as he soared back down to *terra firma* in what would become his first time flying.

In the wake of his transformation, Nate wanted very little to do with the government. They have stolen time from him he'll never get back, they stole his family, and they just tried to steal his life. However, the US government portrayed in this story is not a paragon of morally correct behavior. General Eiling and a group of other military leaders quickly blackmailed Nate. They claimed he had never been pardoned for the original murder charges,

the very same ones that were supposed to disappear if Nate survived the experiment. This made Nate furious. They promised him he would be released if he agreed and survived; now that it was revealed he had, they were going back on their word! The government gave Nate a codename—Captain Atom—and set him up as a government-controlled superhero, releasing a false origin to the public and trotting him out to all the talk shows. Soon, Nate was assigned the alias of Cameron Scott, an Air Force intelligence operative.

This creates a real conundrum of feelings for Nate. Not only does he have no one capable of understanding or relating to any of his problems, but the government literally betrayed him—which is a feeling I think many service members eventually experience. Some mission or worthless duty is going to make you question your decision to join. It's inevitable. Somewhere in your military career, you will feel like this is not what you signed on for.

Is it wrong for service members to think the government has done them wrong? Heck no, we're all human beings, and Captain Atom has every right to be upset with the government for all the terrible actions they have meted out against him.

I've heard of many soldiers becoming cross with the higher-ups in charge, some for not receiving the sign-up bonuses they were promised and some for not getting posted to the location they desperately wanted to be stationed at. This has led to many of them declining to re-enlist when their term ended, or for some to simply go through the motions of a military career in order to secure their twenty years of service and gain retirement benefits.

A mission involving a simple highway made me question the actions of my government. Within all service members, there is patriotism. Without it, none of us would have signed on the dotted line to the red, white, and blue. So rattling around

somewhere in our brains is this basic notion that the mission of the armed forces is to do good and protect America. On a bridge near the Euphrates River, I once had to guard a unit that was paving a new stretch of highway from Kuwait to Baghdad. The road was called MSR Tampa (MSR stands for main supply route). With the help of some Iraqi construction workers, this unit was helping to widen and extend the blacktop. A noble cause, as who doesn't want a smooth and easy ride while driving? However, I soon noticed that the only vehicles using this road were US military vehicles. Every once in a while, a small white Toyota driven by a civilian would shuffle by, but they were few and far between. This awareness soon led me to a question. What was the purpose of me being in this combat zone? Here I was, risking life and limb to protect a road that would only serve the interests of the United States government, not the Iraqi people. I'm certain they would be able to use this road once we left the country, but, in the meantime, it was our road only. That didn't seem right to me. That didn't seem fair to me, and it actually made me angry. I felt betrayed, and I never told this story to anyone once I arrived home. Why would I? How would they understand it? They wouldn't have the context for my feelings or the situation.

However, Captain Atom would understand. Through the fictional constructs of his comic book, he was literally betrayed. Later, during a mission to save a submarine, Captain Atom refused to help. He wouldn't take another step to help out the organization that put him in the position to make the choice. (Luckily for those sailors, they were able to escape through another method, and Captain Atom's decision didn't send them to a watery grave.)

Captain Atom bided his time. He worked within the system until he was able to find and obtain the evidence to release himself from his unjust bonds of servitude to General Eiling and his ilk.

He rebelled against Eiling, resigned from the Air Force (although he still kept the codename of Captain Atom), and found some enjoyment and fulfillment as an actual superhero. Captain Atom joined the Justice League at the request of the US government and eventually moved up the ranks to become the leader of Justice League: Europe.

I suspect that, for Captain Atom, leaving the service was as comforting and freeing as it was to me. It's refreshing to see an airman like Nate used as a positive example outside the service— that we, the readers, get to see him succeed and actually thrive in his new superhero life. With all the betrayal that Captain Atom faced in his origin, especially all the tragedies directly related to his service, he could have conveniently become a villain or extremely depressed. Instead, the writers use him positively, giving him the happy ending he deserves and showing him as a natural leader of superheroes.

(Fun fact, in certain stories and different versions of DC continuity, Nate does become a supervillain. *Countdown to Final Crisis* in 2007 and *WorldStorm* in 2006 are two examples.)

When my time was up in the Army, I was called in to the office of my first sergeant. While looking at a file of all my awards and unit accomplishments, he gushed about the good I had helped to create while being a part of the battalion. I don't remember every detail he said, but I can tell you that it was quite flowery and exaggerated, to the point where it was quite difficult for me not to laugh. When his soliloquy of service finally ended, he looked me straight in the eye and said, "How many more years can I sign you up for?" I replied with "None." This answer seemed to stymie him. Suddenly, the first sergeant began to offer me bonuses and more! Anything to get me to sign on the dotted line. I refused them all. I had always seen my time in the military as

an adventure. Six years of experiences that I could not have had anywhere else, but it was time to move on. Nothing he said could have made me sign up for more, and it was refreshing when I walked out of that office. A world of stress left my body. Never again could anyone force me to go where I didn't want to go. I was ready for a new adventure, something different. Good thing I didn't sign on that line, as my unit was later called up to be deployed to Afghanistan six months after that meeting.

My feelings about leaving the service are probably nothing compared to the immense emotion that Captain Atom likely felt once he got free. No one could understand his pain, his fear, and his sadness. Just the same way we could never understand his joy on the other side of it.

When you are a silver cosmic being of unlimited power, it's hard for anyone to understand anything you go through. No one can know what it's like to melt automobiles with energy from your fingertips, and no words you tried to muster could accurately do the job. With his jump through time, Captain Atom has weirdly become the perfect story representation for what combat deployment means for a service member—an experience where you will be asked to do things beyond your ability, where you will see horrors and triumphs that no civilian can imagine and all these events that were normal to you will be impossible to outline to anyone.

The positive side of Captain Atom is that he represents a way out. Through the adversity, there is a better life waiting for you. (He persevered through fake murder charges; can you complain about anything in your life that's even similar? I think not!) At every moment, Nate could have quit. With every manipulation by General Eiling, he could have surrendered. He didn't. Nate pushed through. It's a trait that I think many people would

ascribe to service members. When the going gets tough, they push through. It's one of our strengths, and it's one of the best character arcs for Captain Atom.

I had a low opinion of Captain Atom before completing the research for this book, and now I admire him. More veterans should read his initial run to give them hope and an ally. There is a hero like you out there who understands, and he made it through to the other side as a better person. That truly is Captain Atom's greatest superpower.

Chapter 7

Green Lantern (Hal Jordan)

In the Shadow of His Father

Hal "Highball" Jordan is a mix of pure willpower and cockiness. Some would say that the two go hand in hand, but I think there is a difference between them. Will is the ability to focus on the task, no matter the difficulty, and succeed. No obstacle can force you off your path. Cockiness comes from pure attitude, like when you're standing on a cliff and your best friend dares you to jump over the edge. Your cold logical brain tells you not to do it, but your cocky side eggs you on. It tells your brain, "If we jump, we can show off. If we jump, we'll be better than him/her." Sometimes cockiness can lead you to make decisions that can get you hurt or, worse, get you killed.

Perhaps that is why Hal Jordan makes such an effective Green Lantern. He has the perfect combination of will to make his ring, the most powerful weapon in the universe, useful; this is combined with the conviction that he can beat anyone. "The fish people of Antares 7 are attacking in their ships made entirely of water molecules? No problem!" Hal would say, before even thinking about whether he'd need a breathing apparatus on the mission. These traits also brand him as a perfect airman, a sometimes-forgotten aspect of his origin.

Green Lantern Hal Jordan was born in the fictional place named Coast City.

(Fun fact: The DC Comics Universe features many fictional cities instead of the real cities we have plastered across our great country. Why the need for fictional towns? The exact reason is

not known; however, it's generally thought that creating stand-ins for real places allows the reader to fully escape into the story. Young comic fans will not be bothered if Mongul destroys Coast City, but they could be concerned if they read a comic where he destroys its real-world counterpart, San Diego.)

Hal's father Martin Jordan was a test pilot for Ferris Aircraft. Hal and his brothers would often visit this place of mechanical wonder and see the many planes their father would buzz through the sky in. Hal loved his father. Hal idolized his father and wanted to be him. All too soon, tragedy would strike the Jordan family. Martin Jordan died in a plane crash right before Hal's eyes. Hal's love of flying and his fear of death would irrevocably be tied together from that day forward. Both his brothers and his mother would develop a huge fear—to the point of hatred—of flying and anything to do with planes. Not Hal, however. All he wanted was to touch the sky. He yearned to be behind the yoke of a plane.

Against his mother's wishes, on the morning of his eighteenth birthday, Hal turned up at the Armed Forces Career Center so early he beat the recruiter to his office and fell asleep outside the door. Clad in his father's jacket, Hal signed up to join the Air Force. His mother considered this move to be a betrayal. She lost her husband to a plane, and she refused to talk to a son who would willingly put himself in the exact vehicle responsible for his father's death. Hal, with his self-importance and belief in his dream, put his wishes ahead of the feelings of his family.

My entry into the armed forces was nowhere near as dramatic. It began in a run-down school gymnasium. During a school assembly that also doubled as a career fair, my friend and I stumbled upon the Kansas Army National Guard recruiter. I'm certain he could see the boredom in our eyes: the lethargy of

two farm boys itching to get anywhere other than farm-country Kansas. He spun a tale of jobs and glory then proceeded to recite all the far-off places a career in the Army could take us: Germany, Japan, and Korea were the main examples. For a boy of seventeen, who barely had a concept of what Korea was, to be offered the golden ticket to visit was extremely enticing.

I was soon inviting the National Guard recruiter to my house. Since I was seventeen, my parents' signature would be required for me to join. My mother was skeptical. Besides an uncle who had been drafted into the Vietnam War, no other member of my family had ever served. My childhood was full of comic books and science fiction novels, so I'm sure my desire to join the Army hit my parents like a ton of bricks. *Where did this come from?* they probably wondered. My father initially refused to sign my enlistment papers; he even refused to talk to the recruiter. Looking back on it now, I can understand his viewpoint. He had been a small independent farmer his entire life. He was his own boss and employer. Why would he sign over his son's choices to the will of the federal government? Eventually, both of them acquiesced, and my enlistment began while I was still in high school.

While it blindsided my parents, my desire to join our military was based around a viewpoint crafted by the comics and novels I loved so much. These modern myths featured heroes who accomplished things no other person ever had. I believed I could do the same thing in the Army—see those foreign lands and pass basic training—two achievements no one I knew had ever done. It was a way for me to be like those champions.

Hal Jordan, as a character, seems like a perfect example of a person primed to join the Air Force. He's a dreamer, like Carol Danvers, but has the strength to push through anything the

military could throw at him. However, the military and Hal Jordan would not be united for long.

Hal Jordan went for years without talking to his mother. Eventually, learning she was sick, he wanted to see her. However, she refused, because he was still in the Air Force, flying planes and performing missions similar to the tragic event that had taken her husband. Hal came up with a quick, cocky plan: since the Air Force has no quick exit plans, Hal decided the best course of action was to punch his commanding officer in the face. By the time Hal was dishonorably discharged from the Air Force and made it to his mother's bedside, she had already passed.

(This would not be a typical exit plan from any of the armed forces. Your branch's basic training should generally teach you to work together as a team and to put aside such cocksure feelings toward yourself.)

Before we tackle the emotional tragedy of Hal's situation, I want to point out that this story has a huge plot hole. Slugging a superior officer would get you in a lot of trouble, but I doubt it would lead to immediate discharge. Dishonorable discharges go on your permanent record. Every background check you ever consent to will show that, for whatever reason, the military decided you were so bad, you had to get the hell out. To provide some perspective: the US armed forces accept people who are about to be sent to prison in lieu of serving a sentence in jail or prison. I think a simple punch would not do the job here.

Moving on, it's time to talk about Hal's familial situation. I did join the US Army against the original wishes of my parents. They eventually came around and let me join when I was seventeen, so their reservations were probably small. Hal's mother refused to talk to him for several years. Let me say that again for dramatic effect: several years! Also, Hal still signed on the dotted line with

the Air Force, knowing that his mother never speaking to him was a very real possibility. Think about what acting this way says about Hal as a character. He was so determined to be like his dad, he did not even worry about the effects that would have on the rest of his family. He never even considered being like his mother. He had to be in a plane. He had to be in the sky. The conviction—the will—behind such a decision is massive. Many people would not make the same choice. Many people wouldn't have the singular focus of Hal Jordan to knuckle down and keep moving forward.

This is one of the key traits of many service members. Time after time, they have to confront situations that are less than ideal—that are not kind to their emotional or physical well-being. However, they muster through it. They push through. It's the only thing you can do, and, sometimes, it is the only thing you have any control over.

An example of that is how you cope with your initial entry training. Every branch has a different gauntlet, even the Green Lantern Corps. Once Hal Jordan was chosen as a replacement by Abin Sur, Green Lantern of Sector 2814, he was quickly spirited off to Oa, home planet of the Green Lantern Corps. (For those of you who do not speak nerd, Sector 2814 is the sector of the universe containing Earth.) On Oa, Hal went through several days of training to use his new weapon, the power ring. He had to work with aliens he had never seen before and think through concepts no human being could comprehend. His main training officer was Kilowog, a colossal alien who looked like a mix of a bulldog and a pig. Kilowog loved to call his trainees "poozers," and put them through all their paces until they learned to make their constructs from the ring as solid as steel. Hal came to Oa as a greenhorn rookie, and he left a powerful Green Lantern.

The training of this fictional military force is very similar to real military forces. The first step is to put you through hardship by creating the toughest and roughest situation anyone could ever imagine. The second step—train you on weapons and techniques in high-pressure situations. The final step is to force your unit to team up to complete objectives, with the attitude that if one of the teammates fails, you all fail.

My Army basic training was one of the most intense things I've ever completed my life. I can definitely empathize with anyone who completes a similar gauntlet, fictional or otherwise. Imagine riding in a packed school bus to a military base. This old behemoth of a vehicle, which is well past its prime, screeches to a stop, the doors slide open, and the sternest, angriest man you have ever seen in your entire life stomps inside. He wears a wide-brimmed hat and you can barely hear his name, but from here and now on, he shall be called "drill sergeant." His stone-cold voice announces to the bus that we have thirty seconds to empty the vehicle or there will be consequences. The drill sergeant left the bus and the chaos began. Like a group of rats on a sinking ship, everyone on that bus scrambled. We collided with each other, and I'm certain many injuries were sustained as the chaotic mass of people spilled out into a formation, of sorts, in front of this drill sergeant. These events launched us into an insane nine weeks of training to become a soldier.

Like Hal Jordan, I had to learn how to work with people I had never met before. Their successes became my victories and their failures became my defeats. Suddenly, new weapons and methods of thinking were shoved into my brain. Here's how you hold a live grenade, soldier! Now throw it! (Remember, the Gravedigger chapter taught us that grenades don't solve problems!) Also, it pushed me harder than any other collective experience I had had in my life, up to that point. Like many

people, I never thought I would complete basic training. It was like this impossible hill. This feat none of us could ever climb. Nonetheless, I completed it. I came out the other side successful and a whole forty-five pounds lighter. (It turns out, when you run eight miles a day, every day, it's very easy to lose weight.) How did you find the mental fortitude to complete basic training, you might ask? The honest answer is "I don't know." I remember taking it day by day, looking at a calendar I had in my locker and marking off the days. That helped, but it's not the secret. I can only deduce that my sheer force of will pushed me through. I had to pull deep from the pit of my stomach and force myself through. I didn't have a pig-faced alien yelling at me in a language I didn't understand, but I had a unit of scary asshole men in wide-brimmed hats yelling at me at every second. It wasn't until I was out of it that the realization of what this training was dawned on me.

The whole point of basic training was to create a situation so stressful, so terrible, and so impossibly hard that if you can complete it, you can do anything. Nothing will ever faze you, not even combat, and that's the whole point. I wish I had known that going in. It wouldn't have made it any easier, but the perspective might have helped.

Many people in training or stressful situations think back to a mentor or a trainer who meant a lot to them. A person who helped them see the bigger picture. This person can give them the perfect advice in their time of need. For Hal Jordan, that person was Sinestro. Now, I know what you're saying! "But he's Green Lantern's greatest villain!" This is true, but Sinestro was also one of the greatest Green Lanterns of his time, and his greatest student was named Hal Jordan. Sinestro was cold, fearless, and stern as a Green Lantern, and he subjected Hal Jordan to many rigorous exercises and impossible tasks which

would have broken beings with a lesser will. Nevertheless, Hal Jordan bulldozed through all of them. This eventually led Sinestro, Hal's trainer, to develop a grudging respect for the human and new Green Lantern. The two of them became best friends.

The friendship would soon be torn apart when Hal learned some troubling secrets about Sinestro's home planet, Korugar. Sinestro had been subjugating his home planet, setting himself, the Green Lantern, up as the ultimate ruler and keeping the population in check with fear. Hal confronted his friend about this behavior, and Sinestro defended himself by claiming his methods were merely a better way to enforce the peace and order mandated by the Green Lantern Corps. Hal reported these acts to their bosses, the Guardians of the Universe—tiny blue beings with white hair and pompous attitudes—who ordered Hal to subdue his best friend. Even though Sinestro had trained Jordan, Hal came out victorious following a tumultuous battle.

Hal Jordan was then forced to testify against his best friend, and the Guardians eventually expelled Sinestro from the Corps and exiled him to the Antimatter Universe. (We live in the positive matter universe, in case you didn't know.) Sinestro swore revenge on the Guardians, the Green Lantern Corps, and his best friend, Hal Jordan. Eventually, he formed a yellow ring and would plague Hal for years to come, especially since the color yellow was one of the original weaknesses of the Green Lantern power ring. This bond between trainee and trainer, between a commanding officer and lower-ranked officer, since the Sinestro storyline, has become a permanent feature of Hal Jordan's character. There's not a Green Lantern story published since that does not have a direct connection to this theme. Every time Hal confronts Sinestro, he is reminded of the man who trained him,

the man who once gave him orders, and the man who used to be his friend.

While I never had a leader of mine completely betray me, I can relate to the Sinestro and Hal Jordan relationship. In close quarters, when you're behind enemy lines, it can be very easy to have the lines of rank disappear. You're both going through a shared traumatic experience, and, as long as the job is getting done, what rank you hold is meaningless. I used to call my squad leader "Melvin" instead of his rank. We were that friendly.

By contrast, I have often encountered a leader with the more nefarious leanings of Sinestro. While in basic training, the barracks I stayed in were falling apart. Paint peeled off the walls, and the enormous murals in the common room were well beyond repair. Soon one of the drill sergeants found out I was a painter. I've always been able to paint. Not Michelangelo level, but if you need somebody to whip up a semi-nice landscape vista, I'm your man. This drill sergeant, whose name I've long since forgotten (let's call him "Smith"), ordered me to repaint the common room mural. Our squad had a bulldog for a mascot, so he wanted to see what ideas I had for that motif. He didn't care how much paint I needed or how many brushes, but he wanted it done in two days. While this might sound like a very achievable goal, let me set the scene for you a little more: the common room was made from cement bricks. Every wall, except for one, had a mural on it. He wanted every one of these murals to be redone. Each of these walls was about twelve to twenty feet long. This was no simple project, three mural walls. So, there I was, painting these murals during the night. In the dark. I could not have any lights on at night, but still had to make his deadline. Somehow, I pushed my painting hands to the brink and delivered, because I was scared of Drill Sergeant Smith. The drill instructors' main weapon is fear. Now, they cannot hit recruits or anything unsavory like

that, but they can make you run ten miles while yelling at you throughout the entire trip from the comfort of a Humvee. My wall mural was no masterpiece, but a combination of bulldogs and castles, the symbol of the Engineering Corps, my specialty in the Army.

When Drill Sergeant Smith saw these mural walls in the morning, he was impressed. He hadn't thought I could pull it off. However, he did not like some of the placements of the animals. Smith demanded that I start all over and finish all three walls in two days.

I could have killed him. Right there, with my hands around his neck. It would have eased all the stress out of my body. I'd killed myself for those murals. What the hell was his problem? But I started again. Three new murals, which I completed in two days. Drill Sergeant Smith was pleased with the second batch (I swear, I would have committed murder if he hadn't been). Thinking about it now, I wonder if that exercise was another test. Did he want to see if I could push myself to make it through? Would I balk when he refused the first ones or would I push through, accept my orders like a good soldier, and get the job done? Well, I got the job done. It took a lot of willpower, but I propelled through it, exactly like Hal through the trials and tribulations of Sinestro. He got through it. I wonder if Sinestro made Hal paint him any murals. Or did Hal's arrogance refuse any of Sinestro's silly exercises?

Hal Jordan might not have had to complete many art projects in his career as a Green Lantern, but he would soon go through the most complicated and crazy part of his career. (Although, can you imagine the magnitude of the macaroni craft projects a Green Lantern ring could complete?) Through some comic book complications, Hal Jordan would soon go insane; his

worst act was the complete obliteration of Oa and the wholesale slaughter of the entire Green Lantern Corps, with the exception of a few members. Crazy Hal would eventually die, only to return less than ten years later in a comic titled *Green Lantern: Rebirth* (2004).

This comic book mini-series, written by Geoff Johns, would retcon many of the egregious and evil acts performed by Hal Jordan, instead blaming most of his misdeeds on the personification of fear known as "Parallax," who possessed Jordan and led him toward mass murder. Hal returned to the land of the living, younger and more energetic than before. Lucky for him, his old friend and mortal enemy, Sinestro, was brought back to life as well. What did Jordan do with his newfound life? He rejoined the Air Force.

Why did he return? Did he miss the brotherhood of the military? Was he looking for a safe space after pushing past the cosmic realms of death and evil? I think so. I think Hal is a man who is always putting his head down and getting things done. He's simple that way, easy to understand. Hal thinks he's the best hero, the best pilot, the best man in the world. In spite of everything, the concepts and boundaries of evil and the veil of death are unknowable to him. I doubt many of us could cope with our brains being broken like that. The complete obliteration of self and worth—the corruption Parallax wrought on him. Could you deal with having the murders of millions of people on your hands? Especially if you did not knowingly commit these murders? It's very similar to coming back from a combat zone. You don't feel like yourself, and you're looking for any kind of comfort. You're looking for the familiar. That's what Hal was seeking in a return to the Air Force. It's a similar feeling to what James Rhodes, War Machine, was also looking for.

Have I ever wanted to rejoin the military, you might be asking? I'd be lying if I said that I hadn't at least considered it. The idea is comforting in some respects. The safety net of the military is one of its best features. What other group will take care of all your needs in one simple go? Food, housing, and brotherhood, all in one. At this point in my life, I feel I'm well past joining up again. I've spent too much time as a civilian. Too much time on the non-military side of things. I'd question the orders of any commanding officer left and right. I'd come up with new tactics which were not Army-approved, that no tech manual would approve of. Basically, I'd be a terror to the US Army, and it wouldn't be fair to the men and women I would serve with. I don't disparage anyone who wants to rejoin like Hal. I see the appeal. However, I think your decision process might be a bit simplified when you were possessed by the living embodiment of fear like Hal was.

Recently, in the comic books, Hal Jordan was asked to take a large step, one that you might have figured comic writers would have assigned to him long, long ago. After a disaster involving the murder of all the Guardians of the Universe (remember their blue leaders?), Hal Jordan was installed as the leader of the Green Lantern Corps. Based on what I've already discussed in this chapter, you can predict why this might be a disaster for our emerald-based heroes. Hal flew by the seat of his pants, not taking into account all the factors and outcomes that would result from his actions. He's a cocky fighter pilot! Basically, Hal Jordan is no John Stewart when it comes to the leadership of the Corps, as I mentioned previously in this book.

After an event with a massive cosmic being by the name of Relic, the Green Lantern Corps found itself hated across the galaxy. Alien beings on many planets no longer wanted the protection of the Green Lanterns, and when the emerald light graced their

surface, these humanoids would riot until the Lanterns left. Hal's solution to this was unorthodox at best. He decided to leave his ring behind and steal a secret weapon deep within the vaults of Oa. This weapon was a power gauntlet that expels beautiful emerald energy; it's the very first Green Lantern weapon. Hal took this gauntlet, staged a fake fight with the Green Lantern Corps, and became an outlaw. A renegade of the galaxy, performing dangerous missions and feats, so the galaxy sees him as the terrible influence, not the Green Lantern Corps. The galaxy should no longer fear the Lanterns. It should fear Hal Jordan.

Let's dissect this very quickly: imagine that the head of Joint Chiefs of Staff, the leaders of every military branch in the United States, decided to resign. Then this former Joint Chief, the shining bastion of the US military, decides to commit acts of terrorism. His acts put the spotlight on his bad behavior instead of the US armed forces. Do you realize how crazy that plan sounds? This is precisely the plan Hal Jordan enacted. It's bonkers. Yes, the different star systems would have suffered from Hal's damage directly, but he's still essentially committing these acts under the banner of the Green Lantern Corps, leading it to seem as though every action of Hal's was sanctioned by the corps.

Hal works better as a loose cannon. The man who, when backed into a corner, can perform an act of insanity that will get his men—his unit—out of danger. He doesn't know how to order other men because his genius and his will to get things done come from his gut.

I've never been in a situation like Hal. I got to command small convoys to and from Baghdad, but never an entire military force, or even a battalion, like Hal. My leadership style was always "Do your job, and we'll have no problems." Hal and I do have one

similarity in this respect: we both hate to give orders. Probably because we both hate to receive them. I always feel everyone knows the job that needs to be done. We're all adults. Why do I need to order you around? You'll only hear from me when the job goes badly, and Hal Jordan operates basically the same way.

Hal Jordan is a bulldozer. If you throw an obstacle or opponent in his way, he will push through them. He will find a way to beat them. You may not like his solution. You may not even approve of his solution, but he will win. This makes him a great example of a service member. Every leader wants that type of soldier under their command. The person who will stop at nothing to achieve the mission. Surprisingly, for all his unorthodox methods, I actually think Hal Jordan is a great example of a service member in comics. His will to win is indomitable.

I have a theory about where that will comes from. I think in some ways Hal Jordan is still a little boy. A boy who stands on the airfield, watching his father paint the sky with his acrobatic movements in a plane. Every move, every decision Hal makes in his life is to prove his worth to his father and, hopefully, surpass him. The only way he can accomplish that goal is to surround himself in an armored layer of bravado. He figures he can never measure up to his father, so he blusters, boasts, and bushwhacks his way through crazy plans in an attempt to push past his fear.

The sad fact about Hal Jordan's character is that, no matter how many intergalactic armies he stops, how many disasters he prevents, or how many times he puts the reality of the multiverse back together, Hal will think he doesn't measure up. The truth is, he does. He's flown past his father many years ago, and isn't that the goal of every son?

Chapter 8

Flash Thompson
A Life of Service

The wise men and sages would all say that joining the military will change you. There's no better example of that in comic books than Flash Thompson. He's the poster boy for how the military will kick you in the ass and transform you. Eugene "Flash" Thompson attended Midtown High School. This high school may not be familiar to you, but to fans of the *Amazing Spider-Man*, it's the school that bookworm Peter Parker attends. You see, Peter and Flash have a relationship. Not *that* kind of a relationship—their bond is that of bully and victim. Flash was the star football quarterback and very popular among the students at their school. However, while his school life was a breeze, his home life was in shambles. Flash's father, Harry, was an alcoholic police officer who beat Flash regularly. (It's interesting to note that the Spider-Man universe loves the name Harry. It's also the name of the second Green Goblin and best friend of Peter Parker. I'm referring to Harry Osborn.) Flash's father, Harry, would scold the boy and make light of his many first-place athletic accomplishments. This led Flash to transfer all of his anger to one person, the boy he called "Puny" Peter Parker.

I am by no means giving Flash Thompson a pass on the terrible bullying that he committed. This torture definitely informed Spider-Man's early career, as seen in the issues created by Stan Lee and Steve Ditko. Nonetheless, for every story, it's good to learn the root cause of any pain or triumph, so that we all have a better understanding of the character.

Once Peter had been radioactively gifted with the powers of a spider and donned the skin-tight suit of Spider-Man, he also

began to show signs of confidence in his day-to-day life. He stopped wearing his glasses and, more importantly, he started talking to girls like a normal person. (C'mon, men, just admit it. We all stumbled as we attempted to put two words together the first time we talked to a woman.) This newly revitalized Peter Parker began to catch the attention of Liz Allen, Flash Thompson's best gal, which sent Flash off in a fury. He became jealous.

There was only one person who was safe from Flash's rage. A person that Flash soon became the biggest fan of: Spider-Man. It's an interesting counterbalance to see Flash Thompson hate one man so much while he loves the opposite side of the same man. One could say Flash was attracted to Spider-Man's independence, his cavalier attitude, and ability to swing from building to building with no responsibilities. (Of course, unknown to Flash was the "With great power comes great responsibility" mantra that would always weigh heavy on Peter.) To this little boy from Queens, Spider-Man was an escape from his terrible father and all the anger he had misdirected at Peter.

Years after torturing Parker, Flash received his draft number for the Vietnam War.

(Due to the Marvel Comics sliding timeline of events, this war has now been retconned to an unknown military conflict. We can't have Flash be sixty years old in the present, can we?)

Flash quickly found himself in the Army and overseas. During one mission, Flash was separated from his platoon. Injured and wandering in the jungle, Flash discovered a mysterious temple. Delirious from his wounds, he fell unconscious and soon awoke to find himself inside the temple called the Sacred Hidden Temple (comic books, kids!). An old man and a kind woman tended to his wounds and nursed him back to health. They

taught Flash little pieces of their philosophy: "It is written—to save one life is to save the world," said the kind woman. Flash was impressed by their altruism, but felt himself called back to the outside world, back to his unit. When he made it back to his platoon, he learned his commanding officer was about to begin shelling a new target, an intense bombardment on an area known as Sector B. Thanks to the art form of dramatic storytelling, I invite you to guess what structure sits right in the middle of Sector B. That's correct, it's the Sacred Hidden Temple! Flash pleaded with his superiors, demanding they leave the sector alone, while revealing the temple's location in the middle of their target. They scoffed at him. There was no temple in that sector, so the bombardment would proceed. Flash hightailed it back to the Sacred Hidden Temple, making it there minutes before the barrage was to begin. He tried to appeal to the old man and the kind woman to leave the temple before the fire and fury of the Army dropped on their heads. However, the old man would not budge. He believed that, if Flash was kind, then his compatriots must be as well. They would not leave. Concerned for his own safety too, Flash left just before the shelling began. This event would haunt Flash for years—as readers were able to see when he retold this story to his biggest idol, Spider-Man.

While serving in foreign countries, it's very easy to empathize with the citizens there. After all, people are just people. At our most basic level, none of us want to hurt anyone. We just want to live our life and love our families. So, I empathize with Flash.

While in Iraq, I was fortunate to know a family with three children: Sahaad, Fahadh, and Abbad. These three brothers and their family lived in a hut outside an asphalt plant we were guarding. The boys would come out to our Humvees, and at first, we did not allow them to come anywhere near us. Yet, over time, when they kept coming back day after day, we got close to them

and began to chat. They would ask for candy. They would ask for our sunglasses. They were just normal boys curious about the fully armed Army unit parked outside their hut. Eventually, I reached out to some organizations back in the US and asked if they would donate some balls or toys for the kids. Everyone responded with a resounding "yes," so not only was I able to gift these boys all kinds of footballs, baseballs, and more, but we always kept a small box in our Humvee to toss to any other Iraqi kids we saw along the road on our missions. We played catch with the kids on several days—there was nothing else to do out there. One day, their mother brought us a serving of bread, which I still consider to be one of the kindest gestures I've ever seen in my entire life. I have no idea what happened to those boys. Once the asphalt plant mission wrapped up after two months, we never went back there. Every once in a while, we would drive by the plant, but I only saw Sahaad once more, walking down the road. Still, these kids were just kind and I always think it's helpful to remember that not everyone is the US military's enemy. Some people are just people.

Flash returned from his military experiences a changed man. He did suffer regrets about the incident with the temple that led him to become an alcoholic—just like his father. With the help of some his friends, Flash was able to beat addiction, and, through the ordeal, he actually became close friends with Peter Parker. Flash didn't need to punish Peter anymore once he saw that Peter was just like him—exactly like the nice people in the temple. He would go on to become a PE coach; teaching young kids his love for all sports. However, 9/11 would end Flash's career in teaching very quickly.

Unlike some comic book companies, Marvel Comics decided to let their characters experience the tragic events of September 11, 2001. How could they not? A majority of their characters

fight crime and live in the heart of Manhattan. It would be hard to write about some of their exploits after that event as if they hadn't been affected. In a very special issue of *Amazing Spider-Man*, Spidey helps the firefighters and Captain America in their efforts to rescue people from the rubble of the World Trade Center. It's a heartbreaking issue and a tough read.

Flash Thompson, like many Americans after 9/11, felt useless. They needed to do something, to make a difference somehow. Flash rejoined the military and was rapidly sent to the Middle East. Peter and his other friends supported Flash's decision, although they missed their friend.

I can remember where I was when I found out about 9/11. It's an almost cliché statement now—who doesn't remember where they were when they first learned the terrible news? I was in a very unique situation on that day. I was at Fort Leonard Wood, Missouri, still in the middle of my Advanced Individual Training.

Advanced Individual Training is where new enlistees to the Army receive more specialized training for their military jobs. Sometimes AIT can be just like college—a very relaxed atmosphere where learning is slightly more disciplined. Other times, it can be exactly like basic training—drill sergeants yelling in your face every second of the day, on top of the more advanced training that relates to your job. My AIT experience was the latter.

On September 11, 2001, my AIT involved a day out on the range. This range was specifically designed around minefields and minefield disarmament. I remember enjoying being out there because any day we were away from the barracks was a nice change of pace. That day we had to crawl across fields of dirt, poking and prodding to discover the buried mines the drill sergeants had placed out there. The dirt was dry, and our

only tool was a long white stick that looked like a composer's baton. You need a small object to hit the metal of the mine from the side. Hitting the mine from the side will not activate the explosive charge, nor will the light pressure from the stick. Once you've come upon a mine, you have to lightly unbury it from the sides, discovering the edges, then slowly disarm it in a complicated, boring process. Our objective was for recruits to find three mines each. Finding the mines was easy. I remember thinking the drill sergeants should have hidden them harder. Walking from the training minefield, I began to hear the drill sergeants yelling. This wasn't their normal yelling. I didn't hear insults about a private's physical abilities—they were yelling about a war. "We're going to war! You're all going to war!" This was the mantra these very frightening men were yelling. None of us knew what they were talking about. In AIT, you're not allowed to watch television or listen to the radio. We had no idea what had happened. An hour later, the drill sergeants wheeled out a television and gathered all the soldiers. They turned on the news and then we saw it: the World Trade Center towers going down and everything else falling to madness as a result. We didn't stay in the training field much longer. Ft. Leonard Wood had been put on full alert because of the attack. That meant no more training, no more classes, and everyone go back to your barracks to prepare. As we were driving back to our barracks, I saw the base transform before my eyes.

Army bases are essentially small towns. There are houses, stores, and churches. Except these normal places are surrounded by weapons depots, barracks, and buildings all dedicated to the art form of war. Several tanks passed our bus. At this time, I had been at Ft. Leonard Wood for about three months. I had seen some of the tanks, but never driving down the street at full speed. At most intersections I saw soldiers in full battle rattle (flak vests and Kevlar helmets) placing giant concrete barricades,

blocking off the streets, and forcing all traffic to take a single route. Our trip to the minefield range that morning took a little less than thirty minutes. The return trip was an hour-and-a-half ordeal. We spent the rest of the night in the barracks, talking among ourselves. Would we be going to war? Do you think they'd activate us straight from AIT? We had all joined a peacetime military force that had just transformed into a wartime military force. We had seen it up close with our very own eyes.

In *Amazing Spider-Man* #574 (2008), comic book readers got to experience Flash transforming right before their eyes as well. The issue begins with Flash lying in a hospital bed. A man in dress uniform walked into the room; this was General Fazekas. The general revealed he was here to question Flash in relation to whether he deserved the Medal of Honor.

In case you don't know, the Medal of Honor is the highest honor any military member can be awarded. There have been 3,522 awarded to the nation's soldiers, airmen, sailors, marines, and coast guardsmen. The Medal of Honor is normally awarded personally by the President of the United States, so one could say receiving the medal is a "big deal."

Flash began recounting his mission, and the comic cut to a flashback (no pun intended). In Mosul, Iraq, Flash and his squad rode in a Stryker ICV, which is an armored vehicle used for breaching unsafe areas. Their mission was to knock on doors and clear the area of any insurgents. A standard "clear and cordon," as Flash calls it. Before they knew it, the Stryker vehicle was hit by an improvised explosive device and overturned. They were trapped in the vehicle until Flash managed to push the door open. This was an attack. The squad evacuated the vehicle while bullets flew in every direction and ricocheted off every surface as they hunted down their target. Flash's squad had driven straight

into a "kill zone." Flash and a fellow soldier named Santos were able to shimmy their way out of the fallen vehicle and use a nearby building for cover. However, their safety didn't last. With a terrible shriek, an insurgent leaped from his hiding place and attacked Santos. The two men struggled—fighting, clawing, and shoving each other—both desperately trying to emerge victorious from this intimate battle of life and death. Fate was not going to let either of them decide. The building these men was in collapsed on top of them and a shower of wood and concrete buried Santos. Flash dug through the rubble but discovered that Santos was gravely injured. Our hero tried to radio for help, but no signal got through. Flash was on his own. He moved out to find a medic. He didn't get fifty yards before he was surrounded by six insurgents this time, each with a weapon pointed straight at him. He leaped to the ground for cover and unloaded every bullet from his M16. Most of their hits were absorbed by Flash's flak jacket, but the insurgents did land several good shots in his legs. Amidst all that pain, Flash decided to stand up and go back for Santos.

It is during this story Flash makes the decision that enshrines him as a true comic book hero. Instead of going for a medevac for himself, he turned around and decided to scoop up Santos. To carry his battle buddy out of harm's way and deliver him to safety. With every painful step, Flash carried Santos on his shoulders, delivering him to a medical helicopter and ensuring his survival.

In the present, Flash revealed that, if he hadn't gone back for Santos, his friend would have died. The general asked Flash what was going through his head. Flash replied, "What was going through my head was that the good guys think of others before they think of themselves."

Up to this point in comic book history, Flash was nothing more than a supporting character—a cliché archetype of a simple bully who made us, the comic readers, feel sorry for Peter Parker, our protagonist and point-of-view character. Over the course of this story, Flash claims the mantle of hero with a smart turn in the writing. Through flashbacks and various cutaways to past Spider-Man stories, we learn that Flash bases all of his decisions on "What would Spider-Man do?" His entire moral code and his actions come straight from the playbook of a certain webbed wall-crawler. The strength to push through the door, the ability to fight six insurgents by himself, and the decision to save Santos' life over his own were all inspired by Spider-Man.

What an amazing example to set for comic book readers. Want to know what's the morally right thing to do in any situation? Think about your comic book hero; they'll steer you in the right direction. To pair this moral code with an Army soldier only amplifies the message. The feelings of awe and wonder inspired by the heroics of our protagonist should happen all the time in comics—it's one of their primary purposes. I'm just surprised that this story comes from Flash Thompson.

The last panel reveal of this issue is Flash suffering a loss based on his choice. The injuries he sustained in the attack forced an amputation of his legs—a sad turn to an inspiring story.

When Flash finally returned to New York, his friends surrounded the new Medal of Honor recipient. Flash even reignited his relationship with his ex-girlfriend, Betty Brant. All of them helped Flash deal with his physical loss and his time overseas, strengthening his confidence—not that Flash needed any help in that department. This dramatic shift also allowed Flash, the character, to embrace a new air of fearlessness. All the aforementioned elements came together to form an amazing

character arc. It's astounding to see this character, who could never pull his head out of his ass, finally become a real hero and even a real person.

Flash would soon have another opportunity to serve his country. He was contacted by the Department of Homeland Security. They had a group of scientists who wanted to use a dangerous weapon to create a new kind of super soldier. The weapon? Why, it was the alien symbiote known as "Venom."

It's intriguing to note that so many characters in the Marvel Universe, heroes and villains, receive their powers in experiments that are chasing the super soldier ideal established by Captain America.

Spider-Man fans know the villain Venom well. With his large black body and aggressive white eyes, his design became iconic the moment it first graced a comic page. Venom was a symbiote from another planet who mostly looked like a pile of black liquid goo. The symbiote was more or less harmless...until it bonded with a host. Its original host was Peter Parker. Parker couldn't control the symbiote, instead finding its super-aggressive nature troublesome and non-conducive to crime-fighting. Peter forcibly removed the alien by using its weakness—loud sounds in the form of some giant church bells. The Venom symbiote bonded with many other hosts, including Eddie Brock, until the US government captured it and designed this new project.

Knowing that Flash was a man who had literally risked life and limb to save his fellow soldiers, the DHS scientists believed he was the perfect man to control the Venom symbiote. Plus, his eternal fanboy adoration of Spider-Man made him the ideal candidate. After pumping him full of sedatives, they released the Venom symbiote to bond with Flash. It did, and its first action was to give Flash a new pair of legs. With this small change, they

discovered that Flash had abilities far beyond those of a normal soldier. With wall-crawling, web-shooting, enhanced strength, and more, Flash found himself the equal of Spider-Man. The government quickly codenamed him "Agent Venom."

Flash jumped at the opportunity to be a hero and to serve. The government was very strict on the regulations and preventive measures they used to keep this new Venom from becoming the aggressive monster it had been in the past. They limited Flash's total time with Venom to only twenty missions. Once he reached that milestone, he would forever be banned from connecting with the symbiote; this was to prevent their two separate consciousnesses from forming a permanent bond. The government also forced Flash to shed the Venom suit following each mission, forcing it back into a protective tube so host and symbiote could not communicate. Flash didn't mind these preventive measures. He shrugged it all off. His injuries had changed him. The changes gave him the strength of will to control a powerful alien. If he had survived Iraq and he had survived the loss of his legs, then he could survive whatever this was.

I know that feeling personally. The confidence of surviving war will do that to you. There's no way it can not change you. While I came out the other side of my deployment in Iraq completely different from Flash (no permanent injuries, thank God), I did come out with an inherent sense of confidence I had not had before. A "malaise of steel" is what I like to call it. For the first year after I returned from the combat zone, I was invincible. Nothing could touch me. Nothing could stop me, and I was making decisions fearlessly. Move to a town I had never lived in before? Done. Ask out a girl who's a complete stranger? Easy. Also, I put more miles on my car during those twelve months than I'd ever drove in the past, simply because I wanted to get

out and see more—places I had never been, things I had never done, they were all for the taking because of this confidence. If I could survive Iraq, nothing stateside could touch me. I wish I could tell you that confidence lasts forever. It doesn't. Little by little, it wears off, until you're back to your normal routines and fears and foibles. There's a piece of it still inside me. A tiny shard that screams to be fearless. Sometimes I listen to it and sometimes I don't. But I can still hear it.

I imagine that feeling was personified by the Venom symbiote for Flash Thompson. It probably amplified and enhanced those feelings, so he became a wrecking ball of fury when the time arrived for his missions. That's the true reason he was such an excellent super soldier. In fact, I would even propose that Flash Thompson is a better super soldier than Steve Rogers, a.k.a. Captain America.

This super soldier would soon come to the end of his career, though. In the landmark *Amazing Spider-Man* #800 (2018), written by longtime Spider-Man writer Dan Slott, Flash would face his final mission. Through various comic book shenanigans, Flash lost the Venom symbiote to its most famous human host, Eddie Brock. However, in the transfer process, a piece of the Venom symbiote bonded with an anti-symbiote serum and turned into something new. This transformed symbiote bonded with Flash, giving him a white version of the classic costume and a powerset more focused on healing injuries. Plus, Flash still had all the web powers he was granted before. Thus he was dubbed "Agent Anti-Venom." This led to Flash and Spider-Man teaming up to duel against the new Red Goblin. This new goblin was the original Green Goblin, who had been transformed by the Carnage symbiote, a relative of the Venom symbiote (comics, kids!). In the chaos of the issue, Spider-Man was forced to re-don the Venom symbiote in an attempt to match the power of the

Red Goblin. When the stakes were high and Spider-Man felt the battle was lost, Flash Thompson came to his rescue.

Flash had used his Anti-Venom powers to heal all the people who had been injured by the Red Goblin, and by tracking the common factor among all these victims, he was finally able to deduce that Peter Parker was Spider-Man. The two men finally saw each other for who they truly were. Peter saw how far Flash had come in his transformation, and Flash, once and for all, discovered his greatest hero, Spider-Man, was the kid he used to push into lockers for laughs. Flash asked Peter for forgiveness, filled with intense regret for all his past transgressions. Peter stopped him, only to reveal that he had forgiven the former high school jock many years ago.

Their touching moment was interrupted by the Red Goblin swooping in to separate the two friends at the emotional peak of their long-awaited team-up. The Red Goblin tried to grab Spider-Man, but Flash jumped in the way, saving Peter as the Red Goblin fired off several thousand volts of electricity—so much power pushed through Flash's body that not even the symbiote could protect him. Peter rushed over to his dying friend and offered Flash the original Venom symbiote. Flash refused. With his dying breath, he said, "People need you. Peter Parker. The Amazing Spider-Man. My hero. My friend." Thus, Flash Thompson passed away. Due to Flash's sacrifice, Peter was able to defeat the Red Goblin later in the same issue.

This life of service transformed Flash Thompson from loathsome supporting character to full-fledged comic book superhero. His time in the military gave him the tools and determination to transform himself into a better person. I cannot think of any better example of a military hero. At its base level, the military is a duty of sacrifice and service. Protection of the innocent through

duty. So Peter Parker's words at Flash's funeral ring true. Peter gave a stirring eulogy for his friend: "Flash started a life of service. Protecting others in a way that people will never know," Peter said. What a thing to say about a hero.

Chapter 9

Isaiah Bradley

The First Captain America

Isaiah Bradley is the finest fictional soldier I will mention in this book, and I bet most of you reading don't even know his name. Isaiah is an addition, a retcon if you will, to the history of Captain America—a secret chapter even Steve Rogers didn't know about. When talking about the past of the US military, we are often forced to look at the blemishes amidst the victories— and to bear witness to them straight-on, without flinching. For every successful D-Day invasion victory, there is a darker, not as morally clear, questionable action, such as the bombs being dropped on Nagasaki and Hiroshima. Fictional comic book soldiers follow this same trend, and the story of Isaiah Bradley is one of the most troubling tales ever rendered on panel. His is a story of personal courage—a value he maintained through every mission, through every slight, and through his months away from his family, even after his government betrayed him and his body.

In *Truth: Red, White & Black #1*, released in January 2003, we are introduced to Isaiah Bradley, an African American man who is excited to join the infantry. He kisses his pregnant wife goodbye and ships out to basic training. What began as a dream of responsibility for the young man soon turns into a tale of discrimination and humiliation. At Camp Cathcart, Mississippi, we first met Isaiah's unit when they have recently finished digging and covering the camp's latrines. The all-Black unit marches back to their barracks as the white soldiers turn their noses up at the stink.

Dealing with latrines is a foul job everyone in the military has to face at one time or another. It becomes another sad

fact of Isaiah's story that the all-Black units of the time—like Gravedigger's unit from Chapter 2—would be forced to complete the missions no other soldier wanted to do. The bitter fact of the matter is that Isaiah's unit would be subjected to racism and violence at every turn. These Black soldiers, whose only difference was their appearance, had to fight twice as hard to get anything close to the rights and recognition of their peers.

Some of the greatest moments in Isaiah's story come when all their misfortune is transformed into teachable lessons. The men of this unit are sweaty and covered in an ungodly filth that would make a dog run for the hills. They are also angry. Not certain of the point of it all. Is there a point? Sgt. Lucas Evans, their African American squad leader, strolls in with the mail and, when one of the men asks Evans why they had to go into the smelly field, he drops a truth bomb on them without warning. It is a lesson many soldiers have to learn the hard way. He tells the men that battles require luck and skill, and if you ever find yourself face-to-face with the enemy in a foxhole on the other side of the world, your enemy may stink to high heaven. Your enemy could stink so much it could flummox you. If you can be thrown by something as simple as smell, your enemy's allies may learn to pounce on that very weakness. Sgt. Evans finishes by saying, "Boys, you are your best weapon. Any hesitation on your part will definitely mean that you die in this war."

It's true. The human brain has been, and always will be, the most potent weapon. There will always be the new bayonet, the new grenade, the new gun, but it all pales in comparison to the cold logic and survival instinct of a human being. These soldiers learned the hard way that comforts and smells are meaningless in the game of war.

It's a lesson I had to learn the hard way myself. While I loathe comparing my experiences or any of my tribulations to Isaiah Bradley, I am a fellow soldier who has experienced the stinky side of the military. Toward the end of my Advanced Individual Training as a combat engineer, my battalion had to complete a long march and several days in the field at Ft. Leonard Wood in Missouri. Step one of this training exercise was a twenty-six-mile walk. This was no pleasure stroll on the beach; this was a march in full battle gear with a weapon and a fully packed rucksack. Many people dropped, and I don't think I've ever had as many blisters on my feet at one time. When we finally arrived at the location where we would set up camp, we were told to dig foxholes outside our tents. At the time, it was very late at night, and immediately after the long walk, so not one of us wanted to do any digging. Nonetheless, there we were, digging with our tiny spades through the wet dirt as it began to rain on us. It was September at the time of this exercise, and if you aren't familiar with Missouri, the temperature can fluctuate widely at that time of year. During the day, the sun will bake the Earth like summer, but at night it can get within spitting distance of freezing. For several soldiers, caked in the sweat of the long march, this was not an ideal situation. The holes were finally dug. The camp was finally set up. All of us wanted our sleep, but that was the last thing our instructors were going to let us have. They said it was time for us to guard our perimeter, and the best way to accomplish that was to get down in our holes, lie in the muddy trench, and stare out into the blackness for enemies. We knew there were no enemies in that forest. We were on an Army base! Did the instructors think we were stupid? Despite our reservations, we did it. We got down in those water-filled holes and stared at the darkness. That's what you do. You follow the orders and you push through it. With grit and courage and sweat, you find a way to make it happen. Keep those eyes open. Doesn't

matter how tired you are. It matters whether you keep yourself and the unit safe. No matter the cost. I can't tell you how many times I nodded off that night, my drooping head sagging until my Kevlar helmet clunked into my M16 rifle, instantly rousing me. It was one of the longest nights of my life. I was covered in mud and sore beyond reason, but I made it through.

Isaiah fought through it as well, to serve his country and out of respect for the service, even when the United States government did not treat him with the proper respect. Very soon he would go from a full-fledged soldier to a terrible statistic. It is at this point that the issue could easily pass for a horror comic where human dignity is concerned; three hundred men from Isaiah's unit were randomly chosen to become test subjects for the famous *Project Super Soldier*. This project should sound familiar from earlier in this book, as it is the very experiment that granted powers to Steve Rogers and transformed him into the mighty Captain America. It only makes sense for the government at the time to not want a white man to be subjected to anything as dangerous or body-altering as the Super Soldier Project. It had to be tested on, in the government's minds, "lesser men."

This is where *Truth: Red, White, and Black* stands revealed as an allegory to the Tuskegee Experiments. These were historically real and morally wrong experiments involving hundreds upon hundreds of African American men who lived in Tuskegee, Alabama. They were told they were receiving free medical care. This was false. The government made these men unwilling participants in a gross experiment. Leaving men with syphilis untreated (despite a known and effective cure) to determine how the disease progresses through the body and its long-term effects.

Isaiah's unit confronted this horror as they were subjected to barbaric medical practices. One of his compatriots lost his life, exploding from the inside out, the muscle growth becoming too much for his small frame, and the doctors went through man after man in an attempt to determine whether these men were dying due to a failure in the formula or the dosage.

This story plays on not only the fear of body mutilation, but also another small fear many service members experience. One secret many civilians do not know is that soldiers, marines, airmen, and sailors are injected with all kinds of chemicals. All kinds of vaccines are pumped into service members. Do we have any choice in the matter? No. Uncle Sam is trying to make you healthier, so you gotta do it! There's a point at which every service member experiences the train of needles. We get in a straight line to be poked with needle after needle. No care is taken for your pain or your aversion to blood, just shot after shot of concoctions being jammed in your arm. The room is padded, and I saw several new recruits drop or pass out from so many injections being jammed into them. We had no idea what was inside those needles. We trusted the government, and we trusted our superiors. (Currently, none of the injections have made me a superhero, but one day they could.)

Isaiah and his unit must have felt the same way. They did what their superiors told them for the good of the unit, for the good of the country, or so they thought. I thank Thor, the mighty thunder God, I never saw anything like this atrocity being committed during my time in the armed forces. For their blind faith and patriotism, Isaiah and four other men in his unit emerged as the only survivors. The super soldier serum transformed them into large hulking versions of themselves. Some of them had grossly misshapen heads, but their strength and agility were increased.

Soon the men found themselves in the Black Forest, able to dispatch the German soldiers with ease and having to come to grips with the morality of performing missions other units would never have been asked to. They knew it was their only ticket home. During this time, Isaiah was the first to question the purpose of their unit. He read *Captain America Comics #1*, the issue that outlines Steve Roger's origin, which caused Isaiah to wonder how he was connected to America's blonde hero. After all, his origin was basically the same as Steve Rogers'—except Steve got his power with less torture. Sgt. Evans told Isaiah to ignore it. Evans threw the comic book away and simply stated, "This is a war. And in a war, the Army decides everything is government-issue."

Evans could have been throwing Isaiah off the scent, or he could have been giving him an excuse to make him forget and instead focus on the mission. Evans is right about one thing, though: when you serve, it doesn't matter what unit you are in or where you serve, you're in a military bubble. Everything you smell, taste, and hear comes from the US government. Can you trust it? Sometimes, but you also have to take it all with a grain of salt. Any distractions can destroy unit functionality, so the higher-ups are going to make sure that what disseminates down to the grunts won't rile them up. Maybe the comic book, in this case, is a whitewash of their history. A perfect recruiting tool for white men across America, but Isaiah didn't get much time to consider that point.

A later altercation with a white officer and infighting in the unit left Isaiah the only surviving member of his original unit. (It is later revealed in the hospital that autopsies on his fallen comrades revealed enlarged thyroid glands which led to the brutal behavior and infighting.) An Army officer confronted Isaiah in the hospital and threatened that his family would be

harmed if he didn't complete the mission before him. The order was given with full knowledge that it was a suicide mission. Isaiah agreed, but not before he got what was his—something that he deserved—a badge of respect he had already earned many times over. Isaiah stole the Captain America costume. Brandishing the flag on his chest, Isaiah parachuted into Schwarzebitte, Germany. What a moment this is. Through each low point in his story, Isaiah wanted the basic respect which should have been afforded him by his courageously being a soldier in the US Army. However, his superiors stole it from him at every possible turn. They pilfered it from his missions, they purloined it from his body, and they blackmailed it out of him. This is a stand-up moment for Isaiah. I cheered when I read this page in his mini-series. Finally, a moment of recognition.

It's a feeling all service members confront at one time or another. It becomes very easy to feel like you have been forgotten, that no one knows what you've done for your country. When a veteran grabs a piece of respect, we all stand up and applaud.

Bradley was captured during his mission, and it took several years for him to make it back to the States. When he reported back in to command, he was arrested and court-martialed, receiving a life sentence for stealing Captain America's uniform. Isaiah would spend seventeen years in solitary confinement. The rudimentary medical care and isolation ate away at his brain and left him a mute man-child when he was finally released, on the day of John F. Kennedy's inauguration. It would be years until Steve Rogers was made aware of the first Captain America: the Black Captain America. Isaiah and his family were ordered to keep the legend secret, but it leaked. The story of bravery, pride, and true heroics spilled out into the world. Isaiah became an urban legend in the Marvel Comics Universe. Many celebrities wanted to meet him, including Malcolm X, Richard Pryor, and

Gen. Colin Powell. King T'Challa of Wakanda, the Black Panther, even secretly invited Isaiah to his wedding.

I wish this type of story didn't exist. I wish the US military didn't have blemishes of this nature on its soul, but it does. This is because all of our honor still comes from a human-based system, and we are far from perfect. Through Isaiah's story, we become Steve Rogers, a white man completely ignorant of the suffering perpetrated on different races for the false "good" of mankind.

Isaiah walked into the US Army with a good heart and his head held high. The system chewed him up and spat him out because of his race. It reminds me of the soldiers who came back from Vietnam who were attacked by protestors. Did the US government do terrible things in a terrible war? Yes. But, did these young men who were drafted against their will deserve to be punished for it? No.

The greatest lesson to take from this story is that, at every turn, Isaiah pushed through. He completed the missions. He took the painful experiments and he excelled in the laughable training scenarios. He sacrificed for his family and for his country, and he came out the other side. That's what a good soldier does.

At the very end of *Truth: Red, White & Black,* Isaiah earns a small reward. Captain America has finally tracked down Isaiah's wife and visited his home. Cap talked with his wife, thinking the great hero was dead. Isaiah's wife laughed and revealed her husband. Even though Isaiah could no longer speak or fully comprehend the situation at hand, you can see him perk up. Captain America thanked him for his service, for his sacrifice. Steve Rogers would not be the star-spangled hero without the blood and tears of greater men like Isaiah. Then, Cap pulls a surprise out of a grocery bag—a torn Captain America uniform— Isaiah's uniform. A smile peeked out. Isaiah donned the tattered

costume proudly. The symbol of his heroism has finally returned to him. Isaiah's wife took a picture of these two Captain Americas together and Isaiah finally got his just reward.

Chapter 10

Sgt. Rock

The Strength of an Enlisted Man

It doesn't matter how big a comics fan you are. Whether you are a casual reader of the medium or a Wednesday Warrior who shows up as soon as the store is open to grab that latest floppy. If you consume comics, you have been told of Sgt. Rock in some capacity. He stands like a legend over this medium and casts his presence over all his fellow DC Comics creations because, for a long time, war comics sold. They sold like gangbusters. That doesn't mean we should consider them to be nationalistic propaganda. These war comics of old are jam-packed with characters and page after page of action, and at the top of the list of war comics rests Sgt. Rock.

I came to learn about his legend thanks to the pages of *Wizard Magazine*, a publication now hallowed because there is no periodical or website that lives up to its legacy. *Wizard* was the one-stop shop for comic news, and myself being a poor Kansas farm kid with no easy connection to a comic book shop, *Wizard Magazine* was as good as gold to me. By flipping through its pages, I could learn almost everything happening in the comics world during any given month. The magazine also had large sections dedicated to luminary characters and comic series from the past. One of the characters they touted was the leader of Easy Company, the man known as "Rock." There was something mythic about him from first glance. Many of the images were of a grizzled man holding a weapon and looking like he had been through hell. What was so mythic about that? It's just a man on a battlefield. Maybe it was the astounding line art by Joe Kubert,

or the fact that I had no idea what war comics were at the time. Either way, this Sgt. Rock seemed like a king among gods.

He is an interesting take on an enlisted man when you think about it. Sgt. Rock is an enlisted non-commissioned officer, and if there is one "real" truth about the military, it's that enlisted service members are the true power of the military. What are non-commissioned officers? They are marines, airmen, sailors, and soldiers who don't become officers or go to college to join the military. These dedicated service members earn their NCO rank by promotion through the enlisted ranks.

They volunteer by signing up and jumping into the deeper end of service. They carry the weight. They actually fight the battles and they suffer the blood loss for the mission, similar to former NFL player Pat Tillman, who enlisted in the Army after the 9/11 attacks. He joined where he could do the most! That's not to say officers don't deserve their due in the military, because they definitely do. However, any officer worth his salt would agree with me and say the enlisted men do the real work.

Let me set the stage for you from an enlisted man's perspective, because I was an enlisted man. In Iraq, generally, when we left the base for early morning missions, we would meet up at the God-awful hour of 0400. The squad would gather in front of the various Humvees and semi-trucks that would soon be bouncing up and down the pothole-filled roads of Iraq. Our lieutenant, an officer, would pull out his manual. I never learned what manual this was, but one can assume it must have been a leadership manual, full of Army rules and whatnot. He would spout our objectives and tell us the rules of engagement and various other regulations we would have to follow while on the mission. The very young lieutenant would then give us our departure time and leave. As soon as he was out of earshot, my squad leader, a staff

sergeant—my non-commissioned officer—would step forward and say, "Okay, forget all that. This is actually how it's going down, so we don't all die." I remember later asking him why he would bend and change the lieutenant's orders every time. He replied that rulebooks don't work in the real world. Their ideas do, but the exact letter and intent doesn't. Sometimes officers have a hard time seeing this truth. They are told to follow the rules every single time. I tend to believe that, and I will state this: that staff sergeant brought us home every single time. Because the enlisted soldiers carry the squad.

In a further nod to the strength of non-commissioned officers, Sgt. Rock led the war stories at DC Comics. Many of their war comics published at the time when he was first created consisted of an anthology format. *Our Army at War* #83 in June 1959, featured the debut of the man known as Rock, an Army character who would stay around for years. Rock co-creator and comics legend Joe Kubert once said:

"The day Bob [Robert Kanigher, co-creator] handed me a script featuring a character called Sgt. Rock held no special significance for me—or Bob. Just another war story about an American soldier. I don't think either one of us ever dreamt that, fifty years later, Sgt. Rock would still be around."

In the issue, we meet our fine sergeant for the first time, and he's affectionately called "Rocky." The sergeant found himself pinned down in a trench with an injured private as the Germans attacked with every weapon in their arsenal. Rocky picked up the heavy machine gun with relative ease and surprised the young private, but Rocky shrugged it off. "I used to work in a steel mill." The noise of the German bullets ricocheting all over the valley didn't faze Rock one bit. "No louder than the factory," he commented. Every aspect of this man was filtered to the reader

through the injured private. Even the dialogue propels this character to a higher pedestal; when an officer from the German side cornered Rocky and our point-of-view private Rocky fought him. His fists flew in every direction as the text of the comic read: "He fought as if no one else was in the war." The captured Germans were dumbstruck. How could this American have defeated their impervious and indestructible officer? The private declared, "Guess he met the Rock of East Company!"

Rocky—or Rock, as he would later be called—was a dynamic figure. He was an unstoppable bull on a battlefield of death and an inspiring ideal for fellow soldiers and civilians alike to look up to. An enlisted man who would protect you. Shield you. March through hell and punch Nazi Germany in the face for you. What else could you need from someone watching your back?

He was born Franklin John Rock in Pittsburgh, Pennsylvania. Rock came from a military family. His father, John (also a Sgt. Rock), died from a sniper's bullet in World War I, and our young Rock was raised by a stepfather. Rock carried on the tradition of serving his country by enlisting at the rank of private in the early days of World War II. During World War II, it was common for men to enlist in the Army. Some would volunteer, but most were drafted. It illuminates a lot about the nature of his character that Rock enlisted. He had every reason not to; experience told him he shouldn't. His father had been taken by the service, and still, he signed the contract, raised his right hand, and sacrificed his time for his country. In the same way Captain America is the mythical officer who can protect you during the war, Sgt. Rock occupies that same mythical space for the enlisted men. The grunts in the dirt and the foxholes can look up to him. The trainees in their barracks far from home, even the ones participating in wars long after World War II, can look at

this character, recognize some of their own traits, and discover motivation capable of seeing them through to the other side.

It might surprise you to know that I did not serve in World War II. Shocking, I know. However, I do have a personal connection. My grandfather, William Inman, was drafted to serve in what would later be known as "The Great War." He was eighteen years old and, at that time, the head of his household. During his teenage years, my grandfather's father (my great-grandfather) passed away. He was suddenly left to fill the position of main provider to his mother and his four younger siblings on a small Kansas farm. I remember chatting with him about this when I was about to sign my enlistment. My grandfather told me he was certain they were going to send him overseas when he received his draft letter. With this in mind, he jumped on a bus, as the orders instructed, and arrived at the military processing center. There, he and several other recruits stripped down to their underwear and did the "duck dance," as he called it. That was his name for all the moving and prancing around in front of military doctors in order to ensure he was physically capable of serving his country. My grandfather passed every test. He was young, he was physically able, and, since he had been in charge of a farm for several years at that point, he would have been a perfect squad leader in the Army. The men in charge did not see it quite like that though. They washed him out of the draft by citing his position as the head of the household. As a result of his father's death, my grandfather needed to stay at home and take care of his mother and younger siblings. With no other recourse, he boarded the bus and began the very long ride back to his farm. Who knows what would have happened if my grandfather had been sent overseas to World War II? Would I have even been born? I guess I should thank the US Army Draft Board of the 1940s for ensuring my grandfather stayed out of harm's way, thus cementing my later birth into the world.

The world that rejected my grandfather's service was the same world that needed the example of Sgt. Rock—who did volunteer to serve and is a character you can empathize with as he takes your bruises. He always moves forward. Sgt. Rock is a humanist who would always preserve life, as well as an honest human being. This speaks to one of the problems with the way the modern world views the soldier these days. Soldiers are human beings first. However, most people in their day-to-day life do not see them that way. When you scrape off the scars and damage of war, you will see an honest-to-God human looking back at you. That's one of the aspects which makes Sgt. Rock so compelling. He's just a man.

In *Our Army at War* #83 (1959), the "real" man behind the Rock persona is revealed. The story is titled "The Rock and the Wall." A few new recruits joined the company to ask the eternal question in all Sgt. Rock stories: "Why do they call him Sgt. Rock?" His loyal compatriots responded, "'Cause when the going gets so rugged that only a rock could stand, he stands."

One of the new recruits goes by the name of Joe Wall. Also, because this is a DC war comic, he had to be named after an inanimate object as well. If the comic had continued until the modern day, I'm certain Pvt. Cellphone and Sgt. Internet would have signed up for Easy Company. Joe Wall was no joke, however, despite his silly name. He was one tough customer. He could easily take out a German tank with a grenade. Wall lumbered back to the unit, mocking Rock. "He doesn't look so tough to me." Sgt. Rock remained silent. If he heard the comment, he gave no indication.

After another vicious attack, Wall and Rock were separated from their unit, but they came across a plane that needed two tail gunners. Being ever-dutiful soldiers, the two men hopped inside

without hesitation and cocked the .50-caliber weapons, preparing for a fight. Wall ridiculed Rock all the while. He taunted Rock, claiming he looked tiny behind his massive gun. If you haven't been able to tell by now, Wall is a terrible person with a big chip on his shoulder. Nonetheless, Rock remained silent. He gave no response to Wall's ceaseless mocking. The fight soon began. Both men fired on enemy planes. Bullets sprayed across the landscape to protect the flying behemoth they had jumped aboard. Over the course of the fight, Wall got hit. He fell from his weapon. He was not able to stand. He was not able to fire. Wall was out of the fight. He tried to return to his post, but he was physically unable. His injury was too severe. Rock jumped over to Wall's weapon and maintained cover for his injured battle buddy. In light of his injury, Wall's thoughts turned desperate. "What kind of soldier am I? What good am I?" he asked himself. In his mind, Wall had given up. He was ashamed. The fight had become a cacophony of bullets flying between the plane he was in and the lone remaining enemy aircraft. Then Rock lifted Wall up, placed Wall's hands on the 50-cal, and while holding Wall steady, Rock let him fire the killing shot. Wall only hit the target thanks to Sgt. Rock's help, and he knew it immediately. Days later, with Wall recovered, he was asked, "Why do they call him Sgt. Rock?" Wall replied, "Cause a wall may fall, but not a rock."

Wall was not the only member of Easy Company to be featured as the comic series continued. Some other notable members under Sgt. Rock's command include Bulldozer, a giant of a man who was second in command, Little Sure Shot, the Apache sniper who never missed a shot, and Ice Cream Soldier, who was nicknamed that for always being "cool in combat." These men followed Sgt. Rock through every obstacle, up every hill, and sometimes to their deaths. They tended to be loud in their character choices and flaws and directly contrast with Sgt. Rock, who tended to be quiet and show restraint toward the enemy.

Rock would go so far as to extend compassion to an enemy, when they were injured or proved no threat to Easy Company. While the men of Easy Company were typical archetypes of soldiers, Sgt. Rock showed himself to be a human being in touch with his soul. It didn't matter what situation he encountered, this enlisted man never lost sight of his morals.

In *Our Army at War #175*, in January 1967, a little girl pushed Rock out of the way of enemy aircraft fire. This brave little girl died from her wounds, and Rock lost it as a result. He was so affected that he collapsed, crying, in the snow of the battlefield. "What kind of crazy war is this—where kids can get hurt because there ain't no real battle lines," he asked in between tears. Since he was in the trenches rather than behind a desk, Rock saw the reality of war. He never glorified it. He felt it. The weight of its impact can be felt by the true juxtaposition of a tall titan of war like Rock, a grizzled man carrying the full weight of the war, being saved by an innocent small child.

These are real lessons taught to the comic book reading audience. The value of duty and the value of following the orders of your sergeant because it would keep you alive. The value of honor: if you take a prisoner of war, you treat that soldier with respect. You will care for civilians, you will bury your dead, and you will keep your soul intact. Some of the other service members mentioned in this book fail to grasp these lessons. Sgt. Rock did not.

In subsequent years of stories, Sgt. Rock constantly turns down promotions, instead electing to remain with his men and choosing to stay on the battlefield where he could make a real difference. Sgt. Rock became a permanent fixture in *Our Army at War*. Every month, comic readers could pick up the issue and the "Rock" of war comics would always be there to guide them

through the tricky moral landscape of humanity, while giving them a solid example of what it means to be a good soldier. His influence would change the title itself. In issue #302 (1977), DC Comics renamed the comic to *Sgt. Rock* as a result of the character's popularity. The title was eventually canceled in 1988 with issue 422 (1988). (Which is an impressive number for any comic series to hit. Most modern ongoing comic books are lucky to make to 100 issues.)

It was not until several years later that comic book readers would learn about the ultimate fate of Sgt. Rock. In the fourth issue of the mini-series *DC Universe: Legacies* in 2010, the surviving members of Easy Company held a party to celebrate those who had fought and died in World War II. While drinks were passed around, it is revealed why Sgt. Rock was not in attendance. In the final days of the war, Rock saved a little girl from Nazi gunfire. He succeeded in bringing the girl back behind Allied lines but was badly wounded during the attempt. Easy Company later learned the bullet that took Rock out was the last shot fired during the war. One of the men mentioned how appropriate it seemed, somehow. The men raised their glasses to toast Sgt. Rock, "Here's to Frank Rock! The toughest, hardest, straightest topkick—most decent human being I've ever known."

When you're serving in the military, you are always looking for someone to have your back. Someone to show you the ropes. Someone to point you in the right direction. If you're lucky, that person will be your sergeant. An enlisted man just like you, who was once in your shoes. A man who knows exactly what you're going through, exactly what you feel, and exactly what you need to hear. The perfect example of that man is Sgt. Rock.

There are so many times when Rock could have lost his way. He could have given up. He could have turned Easy Company into

a platoon full of monsters looking to seek revenge. He didn't. Rock stuck to his guns and led by example. He pulled his Kevlar helmet down to his eyes and got the job done. He's the perfect personification of the enlisted man in the military. Most enlisted service members know their way is harder. They could have gone the route of being an officer, received higher pay and an easier setup, but they didn't. I certainly didn't. We chose the harder road because we were interested in the journey and not the destination. Hopefully, along the way, we met someone like Sgt. Rock—an NCO who looked out for us, or an NCO that we could aspire to be. A soldier who talked to his men like a friend would, not like a boss. Someone who cared, someone who would listen. His stories may look like they're all about the action, but if that's what you see, you're not looking closely enough. The stories of Sgt. Rock are stories of the soul.

Chapter 11

Batwoman

Defying Definition

Many people think the world of Batman lends itself to a military structure. Batman is the general, while all of his various sidekicks and allies are the lieutenants. They execute his vision of a Gotham safe from crime. However, once you dive deep into the stories, you reveal the truth of Batman. For all his order-giving and structured training, Batman is essentially a free agent vigilante, roaming around Gotham and punching anyone in the face without due process or the legal system to protect him or them. "No Miranda Rights for you, chum!" says Batman. Many stories present him as a rule-breaker who is willing to do anything to serve his preferred outcome, as long as no one is killed. The Dark Knight's "no killing" rule is the one rule he will not bend. For all the pompous ideas floating around inside his cowl, Batman would make a terrible soldier. There is one colleague in his menagerie who has been a soldier, still acts like a soldier, and is a perfect exploration of the combination of military and comic book superhero storytelling. Let me tell you about the Batwoman, Kate Kane.

Kate is a relatively new character in the world of DC Comics. However, she is a character who confronts modern issues head-on. Kate attends West Point Military Academy, and while there, she learns that cadets can be expelled under the Clinton-era policy of "Don't ask, don't tell," which was the United States' official policy on discharging gay military service members. (This policy was repealed in 2011, after the creation of Batwoman.) This narrative confronts the two conflicting natures of Batwoman, her role as a soldier and her identity as a lesbian. Kate has a complication of identity.

Although I am neither a woman nor a lesbian, there is a facet of this story I can identify with. Throughout our lives, we are constantly meeting people who want to put us in boxes for ease of identification. I believe this has to do with our animal brain trying to identify threats out in the wild. When you meet a doctor, they then transform into a doctor in every aspect of their lives as relates to you. You can't imagine them doing non-doctor activities, even though they most certainly engage in un-doctorly activities in their off time. Doctors aren't performing brain surgery on the greens of local golf courses, you know. It's similar to young children learning that their parents had actual lives before they were born, or more shocking, that their school teachers actually have a life outside the schoolhouse! The very idea seems impossible from within their small spheres. Nonetheless, once a person can classify another person by a single identifying trait, they will, and I've experienced this phenomenon as a soldier. It becomes very hard for people to look past the uniform. To see the person behind that camouflage clothing. In fact, it's often hard to look past it when you are serving. When you live on a military base, often there is no reason to ever leave. Why would you? The base has a grocery store, a movie theatre, a church, and a barber. What else do you need? These amenities ensure that every aspect of your day-to-day life is wrapped up in your service.

The labeling even extends past your time in the service. Once I was honorably discharged, the moment someone found out I had been in the Army, it became the subject of every question. Their brain couldn't comprehend how a man like me could star in the musical *Chicago* and be a war veteran. (I was a theatre/film major in college, and I'll have you know my performance as Amos Hart was praised immensely.) These two aspects of my life strike people as antithetical, and yet they are parts of who I am.

Very much like Kate Kane, people are infinitely complicated and defy categorization.

As an Army soldier, Kate has the drive to maintain her integrity. "To do what's right, legally, and morally," as stated by the code of Army values. It's a value she learned from her mother. In *Detective Comics #858*, in December 2009, readers are introduced to the origin of Batwoman. In a plain white house that sat snugly within the confines of an Army base, Kate and Beth Kane, twin sisters, were fighting with their mother over dinner. Their mother, Gabrielle, and her husband, Jacob, were both soldiers. Unfortunately, her husband was currently deployed, leaving the matron of the family to deal with the two red-headed hellions. The girls had been trading places in class, tricking teachers and taking advantage of the fact that instructors couldn't tell them apart. (This scheme sounds like the dream of every school-age child who hates math.) Their mother made them stand up and accept punishment for their actions. She ordered both girls to apologize to the teacher they'd tricked. She told them, "That's integrity, and it is the foundation of honor." This is something Gabrielle and her husband believed strongly in. This moment would seal the importance of integrity in all aspects of Kate's life going forward.

Kate's origin is completely wrapped up in the normality of being an Army brat. Several years later, when she and her sister spotted a moving truck outside their house, they knew for certain they would have to move. They hated it because they didn't want to leave their friends behind. However, this is a very normal part of being the child of a service member. You are constantly moving. Forced to deal with new situations, new people, new locations, and sometimes new tragedies.

If you've never picked the brain of an "Army brat," then you really should. It will expose what you take for granted from your childhood. Tell them you've had the same best friend for your entire life. They will reveal the legion of friends they have across the continent picked up as a result of their parent being constantly relocated for postings and missions. Tell them you only lived in one house growing up. They will counter that they were never in one place for more than two years. This is the most shocking normality for me, as my wife, who was also an Army brat, revealed that she has lived in Los Angeles longer than she's lived in any other location. For myself, I still need another decade to beat my childhood record.

Following the theme of military relocation, the Kane family moved to Brussels, Belgium. Her father took a new job working for NATO, and not long after she had settled into her new routine, the worst day of Kate Kane's life occurred. On a trip to get chocolate and waffles, the Kane family car was smashed into a wall by a cargo van. The driver of the van was killed. Kate and Beth's mother was knocked unconscious. The girls were lucky their father was away on business, or else he would have been taken as well. The Kane twins were forcibly removed from the car, only to have hoods shoved over their heads. Kate awakened to discover her father, Jacob, in the process of removing her hood. He was dressed in full battle rattle: Kevlar helmet, flak jacket, with an M16 around his body. He took her hand and softly told her, "Keep your eyes on me, honey." On their way out, Kate briefly saw two dead bodies: her mother and her twin sister had both been killed.

She pushed her grief deep, deep down and used the loss to push herself to be the best. Kate further pushed herself to serve in the US military just like her parents. She blazed through the military academy, becoming one of the top cadets in her class. On the

day she was called to Colonel Reyes' office, everything changed. The colonel stated that an allegation regarding her conduct had been levied against her, a violation of Article 125 of the Uniform Code of Military Justice. (Article 125 makes it a criminal offense to "engage in unnatural carnal copulation" with "another person of the same or opposite sex or with an animal." It is technically still in effect.) The colonel pleaded with Kate. He told her to say it was all a misunderstanding, so he could sweep the entire incident under the rug. Colonel Reyes knew she would be one of the finest officers in the Army. He didn't want to lose her. This allegation would lead to her discharge, and Kate found herself at a crossroads. She could have taken the colonel up on his offer to sweep it under the rug and gone on to become a great soldier. However, being a soldier is about more than serving. One part of it is about integrity—the integrity she had learned from her mother. She looked the colonel straight in the eye and said, "A Cadet shall not lie, cheat, or steal, nor suffer others to do so. I'm gay." Following her separation, she met with her father. When Jacob learned about her discharge, he wanted to know why Kate couldn't have told Colonel Reyes what he needed to hear. In one of the bravest sentences I've ever read from a comic book character, she told him, "I'd have been lying." By way of response, her father praised Kate for her integrity and said he and her mother were proud of their daughter's choices.

The decision Kate made not to lie to her commanding officer proves she has a strong moral code. This is an excellent prerequisite for being a strong superhero and, unlike what "Don't ask, don't tell" policies tried to promote, your sexuality does not define your honor. It certainly doesn't define Kate Kane.

Although the eternal struggle between her sexuality and the military's policy would inform all of her stories going forward, Kate Kane would push onward from this point as a "broken"

character. Her moral code is so rigid, not unlike Batman's rigid view of the law, that even though she made the correct choice in not lying about who she was, Kate still feels chastised, as if she had broken a rule. As a consequence, guilt eats her up from the inside. Her mind twists toward the belief that she cannot be a good soldier and a lesbian at the same time. These two sides of her identity were things she believed would always be a part of her, yet she finds them to be at war internally. Here are two concrete absolutes which are no longer active parts of her external life. Her identity, her personal view of self, is radically changed, and this leads to the complication of her integrity—Kate Kane's most treasured value. Integrity is defined by Merriam-Webster as "adherence to moral and ethical principles," but my alternate definition of the word is also an unimpaired, or perfect, condition. In her state immediately after leaving the military, Kate Kane was far from a perfect soldier. She had lost her purpose. She had lost what she felt was her "best destiny." If she cannot be a soldier, then what is her purpose?

Kate falls into what I like to call "the Bruce Wayne method of healing." She rebelled. She gallivanted around Gotham City, drinking every night and having fling after fling. Except that, in Bruce's case, it's an act to keep up his playboy persona—for Kate, it's real. She was reaching out, trying to find a connection, trying to find purpose in her new world. Eventually, she fell for a Gotham Police Detective named Renee Montoya. She and Renee fell deeply in love, but Kate could not accept the revelation that Renee was not open about her lesbian identity. Kate couldn't understand. Unlike Renee, her integrity forced her to be out, forced her to not lie. So there was no way Kate could be in love with someone who could not be true to herself.

On a fateful night in a darkened alleyway, Kate finally uncovered her destiny. The Batman flew down from the sky to save her from an attempted mugging. Following the scuffle, he reached

out a hand and helped Kate up. It was in this moment when she literally—and finally—accepted a helping hand that she took a monumental step toward embracing her purpose post-service. Kate would never be the perfect soldier. She would never follow the rules again, but as long as she remained true to her integrity—the one part of her identity she had proven would never fail—she could make a difference. Kate Kane could be like Batman.

Kate put on a black and red costume inspired by the Batman and named herself "Batwoman." She patrolled the streets and tried to save citizens, the same way Batman saved her. Her father soon discovered her covert operations and ordered her to stand down: "Just because you were a senior elite in gymnastics doesn't mean you're a crime-fighter," he stated plainly. Unsurprisingly, she refused. Kate shut him down by proclaiming that she had finally uncovered her way to serve. This was her call to arms. Her words made her father, the old soldier, respect her. He eventually acquiesced and let her continue. Secretly, he agreed to help her only if she would agree to more training. She did agree. The father and the daughter united with the goal of saving Gotham and returned purpose to Kate Kane's life.

Batwoman encountered other Bat-family members during her earliest adventures, but she did not play well with them. Despite wearing the symbol of the Batman, she had not been trained by him. Even in the world of Gotham vigilantes, she was an outsider. Her post-military rebellion led her to consistently damage relationships. Kate was not about to be locked down or told what to do by anyone anymore. Her identity was now to challenge everything. Eventually, Batman did invite the Batwoman to join his team in *Detective Comics #934* in August 2016. He thought her military training would be an asset with the potential to aid him in recruiting and training a new team of younger Gotham vigilantes. This was an unorthodox team, to

say the least, with the mute Orphan, Cassandra Cain, and the villainous Clayface, a former Batman villain, fighting alongside Red Robin, Tim Drake. In many stories, her military strength and training came to aid the team; she pulled them free from many tight spots. Yet, Batman and Batwoman would eventually be at odds. In *Detective Comics* #974–975 (2018), Clayface went rogue. His powers malfunctioned, and he became a danger to hundreds of civilians. When confronted with this great danger, Batwoman leaned on her military training. She killed Clayface— shot him—because killing one person in order to save thousands of endangered Gotham citizens was an acceptable loss to her. Her decision flew in the face of Batman's "no killing" rule. However, she's the only person on this team who could have made this decision. The other teammates' optimism could have led to the death of hundreds. Shooting one person is no big deal to Kate. She can deal with the consequences. She can deal with the moral implications and with Batman scolding her, because she is still a soldier. This action complicated her life, of course. Just like her brief time in the Army, her actions—which she deemed correct—directly led to her being kicked off Batman's team. Her identity as a Bat-family member was suddenly at odds with her identity as a soldier. Her struggle with authority and the predetermined rules of being a vigilante, as set down by Batman, was overwhelming.

That was my biggest struggle in the military, as well. Not Batman, but having to follow the ironclad rules of the institution, even when they made no sense—especially when I knew they were wrong or when they were being handed down by lieutenants who were the same age I was. Sometimes they were officers I knew had never left the base and never seen the things on missions that I had. It was very difficult to swallow that. Nonetheless, that is what serving in the US armed forces is like. You have to trust that your commanding officer has your back. If

you can't follow the orders, then you shouldn't serve. Eventually, I had to leave because of it.

Kate was never afforded that choice in the military, although she experienced it when she left Batman's group. A way of living steeped in integrity ultimately made her an outcast again. She continued to struggle to maintain her identity afterward, clawing toward a sense of stability. By this point, she had lost her twin, her military rank, and her status as a Gotham vigilante. It's no wonder Kate struggled to follow each system of rules. Her identity complicated all of it at every turn. Her sense of being a twin was ripped away from her, her sense of being a soldier was torn away, and then the Batman seal of approval. With none of these labels left, her queerness became most important.

For all of Kate's struggles with identity, her sexuality remains constant, and she's a great representation of a modern LGBTQIA+ person. It's the one part of her life she's never afraid to show or talk about, whether that be to her father or to the military, she will always have the integrity to stay true to herself. This is what makes her truly independent and resilient.

Batwoman is a soldier who reminds us no one can be defined by any singular trait. Service members are complicated beings and the correct paths in our lives aren't always clear. She proves that staying true to yourself means sometimes having to break the rules, and being true to yourself is more important than giving up your integrity.

Kate's problems with identity may be fluid. She may wander, she may fall, and she may be unsure of what her purpose is. Nevertheless, her actions prove there will always be a problem when you keep dedicated soldiers from serving our country. Kate Kane's integrity was true when her country's values were not.

Chapter 12

Beetle Bailey

The Polite Rebel

It's time for us to talk about the most famous Army soldier in all of pop culture: Beetle Bailey. Private Carl James "Beetle" Bailey is the ultimate slacker. Instead of performing his military duties, he's usually lounging underneath a tree or attempting to flummox Sergeant 1st Class Orville Snorkel (until this moment I had no idea Sarge was that highly ranked. Good on you!). Bailey is the representation of the average GI Joe, as well as probably being most Americans' introduction to the life of a soldier.

The comic strip titled *Beetle Bailey* began on September 4, 1950, right near the start of the Korean War (June 25, 1950, to July 27, 1953). It was written and drawn by comic legend Mort Walker. Sadly, Mort is no longer walking the mortal plane. However, the tales of Beetle Bailey continue, due to the diligent work of his granddaughter, Janie Walker-Yates, and her husband, Mike Yates. The strip's content and original jokes were based on Mort Walker's time in the Army. Looking at the characters who populate Beetle Bailey's stories, you get a very intriguing view of Mort's time in the military.

Besides the title character, *Beetle Bailey* features one of the largest supporting casts of all comic strips. Sergeant Snorkel, Beetle's nemesis, is an obese snaggle-toothed man from the unfortunately named Pork Corners, Kansas (fun fact: not a real place!). There's Otto, Snorkel's bulldog, who dresses in the same uniform as his owner and acts more human than Sarge does sometimes. Ruling over the base is Brigadier General Amos T. Halftrack, an alcoholic old man who doesn't really care how his base (Camp Swampy) runs, as long as he can make it to his tee

time. Miss Buxley is the general's civilian secretary, who draws the eyes of all the men on the base and eventually becomes Beetle's girlfriend (the schemes he must have had to pull on her to get her to agree to a date boggle the mind). Rounding out the cast are Cookie Jowls (the mess sergeant), Private Zero (the dumb farm boy), and Private Plato (the philosophical book lover). Each character ranges from a little odd to quite absurd, although, to tell you the truth, I met many people just like them during my time in the military.

You see, joining any branch of military service is a strange experience. You're suddenly asked to do things you never thought in a million years you would ever be doing. You're asked to work beside people from all over the Earth; many who would not talk, or even think, the way you do. Moreover, nationals of several foreign countries can gain citizenship by serving a set number of years in a branch of the US armed forces. It's a melting pot of surrealism mixed with very real stakes. Some of the *Beetle Bailey* strips are more realistic than silly because the high-stress nature of the military can lead very quickly to high school and adolescent hijinks.

Beetle represents the typical enlisted man: thrown into basic training, shoved onto buses like cattle, treated like dirt by their sergeants, only to turn around and be praised by the blue-haired ladies of the community for protecting America's freedom. While they preserve freedom for all of us, they lose every ounce of it the minute they join the Army. They have to wake up at predetermined hours, they have to go to places and countries they don't want to, and they have to perform the dirtiest jobs no one would ever volunteer for. (Would you choose to dig a latrine? Remember Isaiah Bradley in Chapter 9 did not have a fun time doing it.) Mort Walker introduces the idea that a lower ranked soldier's duty is to be a slacker, to avoid doing work at all costs,

and then to stay up all night having fun when they get the pass to go off base. The pure antithesis of a good non-commissioned officer. (Sgt. Rock in Chapter 10 would have hated Beetle.)

There's one Beetle Bailey strip where the reader sees Sergeant Snorkel constantly saluting. When the "camera" pulls out, it's revealed that Beetle has been walking back and forth past his window holding an American flag. Sarge was forced to salute every time he saw it, and Beetle knew it. Beetle isn't a dummy. This is a clever prank to pull on your overly patriotic sergeant.

In Iraq, we had several officers who would always try to "hang" with the men, the enlisted men, I mean. These lieutenants and captains who commanded us would try to act like they were our friends. Hemming and hawing about the dirt and the sand on the missions. How tough it was to go outside the wire in full battle rattle. What it was like to not call the wife for over two weeks because the satellite phones were down. Here's the thing, they could easily have done all of those things I mentioned! They were the brass in charge! The enlisted men in my unit were the ones in the muck with few to no creature comforts, and quite frankly, it was a bit insulting when they would try to act "like one of the boys."

So, we would "sniper check" them. During the Vietnam War, regulations were implemented so that no enlisted man needed to salute a higher-ranked officer in the field. The Viet Cong snipers would watch the US units and, if they saw a salute, they would shoot the officer. Hence, no more saluting to protect the officers. It's actually a very smart tactical rule. The term "sniper check" has become something of an inside joke in modern military units. Whenever you have an officer you don't like, or sometimes one you can joke with, in the field, walk right past them, throw up that salute, and say "sniper check." (Note of warning for anyone

who wants to try this: it's against regulations, so make sure you have a friendly relationship with the officer you are going to try this on, or else you may quickly find yourself on guard duty for a year.) Moves like "sniper checks" are simple ways to keep soldiers from going crazy in high-stress situations far from home. It also leads to a sort of *Animal House*-style environment where you love and hate the men you are serving with.

Look at Beetle Bailey and Sgt. Orville's relationship. Beetle makes it his daily mission to irritate this man (with half a century of grief at this point, I'm surprised Sarge hasn't dropped because of a heart attack). Sarge returns Beetle's grief in kind. Sarge gobbles up the cookies from Beetle's mother. He sometimes beats Beetle within an inch of his life, not to mention the hundreds upon hundreds of windows across Camp Swampy that have been obliterated because Sarge threw Beetle out of them. These two characters need each other; they also spend way too much time with each other. Their gentle pokes at each other alleviate the stress.

One of my sergeants was a man named Graham. (His name has been changed to preserve the legend of our hijinks.) He was a friendly fellow, but when it came right down to it, he wasn't very smart. He'd order the unit to do several things that would fly completely in the face of logic. Time and time again, if you could name the most complicated way to complete a task, that was how Graham would order you to do it. Across many bases in Iraq, there were walls of graffiti. Units passing in and out of the base would tag their platoon designation. Sports teams and mascots would be painted. It became a rite of passage to spray something on these walls (when I say walls, I'm being quite generous. These were wire tubes filled with gravel to prevent bullets and explosives from hurting anyone inside).

Now, I wasn't the only soldier who became tired of Graham or his way of running things. Most of the men in my unit thought he was quite annoying, and after three months of shenanigans, I came up with a plan. I told our unit that we should paint "Graham sucks" on every base wall we drove through. (Admittedly, it was not my best work, but I was young and stressed and in a war zone at the time. I ask you to cut me some slack.) The unit liked the idea, and Operation "Graham Sucks" caught fire. Driving into Camp Victory? We painted "Graham sucks." Crossing the Iraqi border into Kuwait? We tagged "Graham sucks." Soon there wasn't a single base we regularly visited that we hadn't tagged. Months passed, and the missions continued, so we kept tagging the phrase everywhere. It eased our stress. One day, we were assigned to guard a convoy north of Fallujah, a base we had not yet been to. As we drove into the base, on the wall at the entry, we saw a large piece of spray paint that blew our minds! There in bright blue letters: "Graham sucks." No one in our unit had ever been to this base previously! Who had tagged it? The only possible solution came to me: other units. Other service members had seen our buffet of "Graham sucks" and carried on the tradition. The tagging was spreading! We had created the "Kilroy was here" of Operation Iraqi Freedom. Our Humvee and convoy erupted with laughter. It was an epidemic—belly laughs for hours. We couldn't stop ourselves.

What did Graham think about the tagging? At first, he hated it, and I don't blame him. However, over time, he warmed up to it and realized that it was only us trying to blow off steam. He let them go, and he let us have it. Graham could have brought us up on charges. Instead, he realized we needed it. So, he let the tradition continue.

For the record: I've read many books and seen many pictures from the years following my time in Iraq. I still see "Graham

sucks" to this day. You won't see them, however, as I changed the name of our sergeant to protect him from further insult.

While *Beetle Bailey* might be a comic strip character who is more of a slacker than a soldier, he actually might be the most real Army soldier in comics. The Army doesn't have talking dogs and sergeants who beat their underlings, granted, but it does have an extreme amount of stress and pain. Soldiers currently serving need a way to unleash their inner anguish, and a slight jab at "the man" is a way of letting off steam. In the 1950s, the US military's official paper banned *Beetle Bailey* from their publication. They thought it would lead to a wave of soldiers disrespecting their commanding officers. In fact, this comic character would probably be the last piece of media capable of doing that. Every service member is Beetle Bailey at one time or another. Sometimes you hate your commanding officer. Sometimes you hate your work. Sometimes you just want to go home. Beetle Bailey shows us that with a little dose of polite rebellion, you can gain some of your freedom back. You can become a human again and not just a soldier. As well as seeing yourself as a human being again and not a walking, talking uniform. It's a powerful lesson every service member needs to remind themselves of to keep from going crazy.

Who knew Beetle Bailey's napping on the side of a tree was not a dereliction of duty, but the proper thing to do for his mental health?

Chapter 13

Nuke

Patriotism Unchecked

There's nothing wrong with loving your country. You might even say that, for Americans, patriotism is baked into the DNA of our great nation. Our founding fathers grabbed the freedom to help found our country, they flew in the face of the British, and we have never let go since. (They also stole a bunch of land owned by the Native Americans, so their record isn't spotless.) It's become our right. It's become perfectly normal to display a flag outside your house every day (a move that confuses my Canadian wife). It also can go too far. Outward, vocal, and enthusiastic patriotism is an aspect of our culture we tolerate and even encourage (no matter which country you come from). However, patriotism can also be used in an "us against them" way. Or the classic "If you're not with me, you're against me" way. A healthy love of country should lead to a sense of unity and common understanding. Instead, human beings often take extreme patriotism down a road of ugliness, hostility, and vitriol against those they deem not patriotic enough. No comic book soldier exemplifies this problematic ideation more than the Marvel Comics character Nuke.

First published in *Daredevil* #230–233 in 1986, Nuke's introduction was simple. It was hearing his name spoken in hushed tones. The Kingpin, also known as Wilson Fisk, wanted to call in an agent by that codename. His employee, Wesley, warned Fisk that Nuke had never before been deployed domestically. This trivial detail did not bother the Kingpin. Nuke would be his weapon against a longtime nemesis, and Fisk reveled in his fantasy of being able to control the military. The institution was to become a pawn of his greed and his wealth

in the same manner in which legitimate businessmen of New York City had. This is where the story of Nuke first leans into commentary on the modern American military complex.

We meet Nuke seated in a helicopter. For all intents and purposes, he is a perverted and overblown living version of the American dream. He is a blue-eyed, blonde-haired man with the stripes of the American flag painted on his face. He asks his pilot for "a red." The pilot hands him a red pill. It was very much like watching America's ever-growing opioid crisis scowl in our faces as readers. This soldier—this Nuke—was a drug addict. Nuke muttered to himself, "Our boys—our boys." when the pilot informed him they had arrived in Nicaragua, rather than Vietnam. Yet this veteran could not see beyond his past mistakes and his previous missions; he would always be living in that singular war, partially because of the drugs and partially due to how the napalm warfare of that particular conflict had forever changed him. Nuke adjusted his giant rifle (a ginormous weapon which could only ever be found in comic books). Its name was Betsy, presumably for Betsy Ross, the woman widely credited with making the first American flag, and had a digital counter on its side, so Nuke could track his kills. He leaped from the helicopter, ready to wreak havoc.

At this point, I have to be honest. I hate this character, and, because I hate this character, I'm despising writing this chapter. Why, you may ask? Because I find the character Nuke despicable. He's the cliché of what every peace-loving hippie considers soldiers to be! (I write this with no offense meant, I consider myself to be a peace-loving hippie.) He loves to kill, but he hides this fact behind his drive to save "our boys." (What about the women, Nuke? What about the genderfluid? They serve too!) This man desperately needs help and many visits to a therapist. However, the trappings of the story are wrapped up in a situation

ensuring he can never escape his war. By controlling him with pills and rewarding him with violence, all while he proudly brandishes the flag, Nuke was born a contemptible character. I understand the writer of this story (the great Frank Miller, creator of *The Dark Knight Returns* and *Sin City*) is using Nuke to present us with an idea. The theme is showing us how far modern America has been corrupted, sold to the highest bidder, even to scumbags like the terrible Kingpin. The story of Nuke is also to exaggerate what a 1970's Captain America would actually have been like: a troubled man on drugs who struggled to do the right things, all while being tricked into killing the wrong people. If there's a better representation of the problematic nature of the Vietnam War distilled into one character, then please tell me. He's a parody of Rambo, Sylvester Stallone's action representation of a Vietnam-era soldier. I find Nuke to be completely and totally disgraceful and, to that point, the writer succeeded.

There's a scene later in the issue where Nuke was flying on a plane back to New York, in the same skies where his eventual battle with Daredevil would take place. He ordered a beer up there, and, when the flight attendant informed him his brand was not in stock, Nuke completely flipped out. It took the colonel, his handler, to assure him that another beer available was made in America to calm Nuke down. He was so obsessively patriotic he could only drink a beer brewed in the United States! That is an insane level of patriotism. (Also, did Nuke never consider that the very plane he's flying in might have been built in Mexico, Japan, or China? Does he only fly American too? Does he rip up the floorboards to find that confirmation?)

Everything about Nuke reminds me of a mission that I carried out in Iraq. (It involved none of the malicious intent and blatant property damage of Nuke's stories, true believers. Fear not.) We

were delivering food and aid to one of the local villages very near Nasiriyah. It was seen as a gesture of goodwill by our lieutenant colonel, a move he thought would engender good relations with the local civilians and possibly convince them to report any possible IEDs (improvised explosive devices) insurgents may have planted outside our gates. As we were handing out boxes of MREs (meals ready to eat) and water, one of the sergeants in my squad was approached by an Iraqi man. This man spoke no English, but he was trying to obtain something from the sergeant. To this day, I have no idea what this man wanted. However, I could see the sergeant becoming very annoyed, so I sprinted over there and handed the man a giant box of water. I figured if I could bribe him with supplies, maybe this would satisfy the Iraqi. It did. He smiled, patted me on the back, and walked away. I guess we're all looking for someone to hand us a giant box of water, right? The sergeant was still fuming. "Why don't they speak American, dammit!" he yelled. Now, when I was deployed to Iraq, I was a very young man, still in the middle of my time at university. I loved to challenge preconceptions and assumptions at every turn. Basically, I was an annoying kid who liked to get a rise out of someone while proving myself right. I thought I knew everything (don't we all when we're in our early twenties?). I walked over to him without missing a beat and said, "What language is American?" The sergeant was dumbfounded. It was like I had told him the sky was red or something. He didn't understand me and clearly didn't realize I was saying this in jest. "You know, American!" he repeated. I informed him there was no language called "American" and asked whether he understand the very nature of the words coming out of his mouth. "We speak the Queen's English, not American," I replied. He chuckled, but quickly left, knowing I had just embarrassed him in front of the whole squad. I'm happy to report the sergeant and I would later go on to become good friends, but he never forgot my "Queen's

English" comment. In fact, he brought it up every time we went out on a mission afterward. I'm just lucky that particular non-commissioned officer was a good man and not a sadist. My enlisted butt could have been in some very hot water.

Speaking of hot water, let's go back to Nuke, who soon found himself meeting his new employer in his office. It was child's play for Wilson Fisk to manipulate Nuke's patriotism. While holding an American flag, Wilson told Nuke a story about how Nuke reminded Wilson of his own son, who also served in Vietnam, and how the noble practice of capitalism was being torn down by the police and their allies—the vigilante superheroes. "I am not a villain. I am a corporation," Kingpin waxed on. With his rhetoric, he grabbed Nuke's mind and pointed it like a sniper's bullet straight at Daredevil. This soldier had become a pawn. Give a great speech, stand next to an American flag, and Nuke the soldier will do your bidding for free and provide readers with the most obvious connection between America's military forces and private industry.

Following this, Nuke got back on a helicopter and rode straight to Hell's Kitchen. His battle with Daredevil was about to begin. Nuke tried to get his handler to let him use napalm, but the colonel explained that this was US soil. They could not do that kind of thing here. Nuke didn't care. Nuke didn't care about collateral damage. He thought killing an innocent civilian in pursuit of a target is an acceptable loss. His mission gave him the means to do anything he perceived as morally right, a classic version of the ends justifying the means. Daredevil and Nuke traded blow after blow, with Nuke firing wildly in every direction as he tried to hit the acrobatic Daredevil just once. For his part, Daredevil smashed Nuke again and again with his iconic billy club. Ultimately, Daredevil found himself outmatched. Every blow he landed left Nuke feeling no pain. Hits which might

normally stop a mortal man had no effect on Nuke. This flag-wearing monster was not what he seemed!

Their fight was so disastrous it created a war zone right in the middle of New York City. Cars were on fire, civilians lay on the ground with bullet wounds, and cops screamed for backup. They had conducted a private little war on American soil, something the United States has been lucky enough to avoid since the Civil War, but this soldier brought it home. The madness, veracity, and anger normally reserved for a far-off battlefield were smashed right down on a normal city street. The terrible battle between Nuke and Daredevil was so detrimental that the superhero team the Avengers showed up on the scene. Iron Man had to threaten to fire on Daredevil in order to stop him from pounding Nuke's face in. Amid the chaos, Nuke begged Captain America for a white pill—one of his downers. Afterward, the Avengers hauled the monster away.

Later, Captain America broke into the government facility where Nuke was being held after the conflict, only to discover that yet another version of the super soldier serum had been deployed on twenty soldiers, leaving one man alive—Agent Simpson, codename: Nuke. Cap would discover that Nuke was a soldier during the Vietnam War. A soldier forever traumatized by the missions he had performed overseas. His actions had left his psyche damaged. Nuke agreed to the experiments of Project Rebirth—and, like Isaiah Bradley in Chapter 9, the first Captain America—these experiments had altered his life for the worse. His mental condition deteriorated, he tattooed the American flag on his face, and all too soon his superiors realized they had failed to create the new Captain America. They had created an American monster. In reaction, they made Nuke a black-ops soldier and deployed him to foreign countries to hide their patriotic mistake from the American public. In the end,

Captain America broke out his fellow soldier and helped him get on his feet. With Daredevil's help, Cap delivered Nuke to *The Daily Bugle* and the truth about this tortured soldier finally came to light.

When looking at the overall creation of Nuke, I like to wonder why he wasn't a character created for *Captain America* comics. Was it writer Frank Miller's intention to have Daredevil, a lawyer trained to win battles with only the words and laws of the constitution, battle a physical, military stereotype built to fight battles with only his fist rather than his mind? I think it was. However, as a dark Captain America analogue, Nuke and his perverted sense of patriotism would have been better served in my opinion.

Patriotism, like every moral aspect of our country, is malleable. The men and women of the 1940s were considered to be the best of the best. They were named the "greatest generation" by NBC News anchorman Tom Brokaw. The men and women who served in the 1970s were dubbed murderers. Tomatoes were thrown at them when they returned. No parades greeted their return, only hate. Both generations were good soldiers doing their duty. Yet one generation is loved and the other is hated as a mark of how much American patriotism had changed over thirty years.

Nuke is the personification of the worst parts of American patriotism. He's a problematic soldier with similar beliefs to many problematic citizens in our country today. The Americans yelling "blow it all up," the Americans turning away refugees at our borders, and the Americans yelling "speak American" are an extreme version of our country's beliefs and values. My training in the military taught me to have honor, dignity, and courage. To not fire upon someone unless it was absolutely necessary and that all soldiers, from any country, are your allies. My America is

closer to Captain America's than Nuke's. It's the reason I despise him so much. He's stuck in a war with its fighting long over, using methods now considered morally repugnant. He's stuck in the past. Patriotism should always move forward. It should not remain in one place or one conflict; it should always reflect the best of America. As a means to look at the past and improve upon it. That's the America I believe in. That's the America that makes me patriotic.

Chapter 14

The Punisher

A Love of War

Everyone knows the symbol Frank Castle wears. Whether or not you've never read a comic before, you've seen the skull symbol of the Punisher. Whether it was on a pickup truck or maybe on someone's backpack, the skull has permeated our pop culture and beyond. Why? At his core, Frank Castle is a normal service member driven to a revenge quest. A marine so damaged beyond repair, his only way of functioning is to always be fighting a war. A war with corrupt officials, a war with superheroes and their values, and a war with criminals. It is an eternal conflict for Frank Castle. He is a post-traumatic stress disorder drama wrapped up in an action revenge tragedy. The Punisher forces us to face some difficult questions. What is "right and wrong" when it comes to our vigilantes, our superheroes, our soldiers, and their families? Can we cheer on a hero as evil as the bad guys? We can. Should we? That's a tougher question. Furthermore, was it right for Frank Castle to bring the war home with him? When a service member signs up to fight the "good fight" for their country, most of the time, it's to protect their home. It's to keep the enemies far from home and keep their family safe. Frank failed on both those counts. Internally and externally, the Punisher brought his war back home, and eventually his family became the true victims of it.

Frank Castle originally fought in the Vietnam War. This has since been retconned to some unnamed war in Asia, due to Marvel Comics' sliding timeline to prevent Peter Parker from ever aging beyond forty. Personally, I prefer the Vietnam conflict as the background for Frank's trauma. The issues raised by one of America's most divisive conflicts are the perfect ground for

the origin of Frank Castle. America has always had problems with the actions of its military in Vietnam, so why shouldn't that very conflict be the birthplace of one of Marvel Comics' most troubling heroes?

He was as decorated a marine as he was a dedicated family man, fighting every battle in the Vietnam War with more passion and grit than most marines. He eventually retired to become a Marine Special Forces instructor back in New York, specifically with the goal to be closer to his wife, Maria, and his two children, Lisa and Francis. Not long after his war, Frank and family went on a picnic in the middle of Central Park. There they became accidental witnesses to a mob execution. The mobsters turned their fire on the Castle family to ensure there would be no witnesses. Frank's family perished before his eyes. Somehow, Frank was able to survive his wounds, but the violence of war had followed him home. The battle was about to consume his entire life. Frank soon discovered he was unable to move on from the death of his family. It would be a tough task for anyone who wasn't in the midst of the effects of PTSD. Right as he was about to receive the Presidential Medal of Freedom, Frank disappeared. He felt betrayed by a corrupt criminal system and had decided to take matters into his own hands. When Frank returned weeks later, he sported all black and a large white skull had been painted across the chest of his body armor. Calling himself "The Punisher," Frank vowed to get his vengeance on those who had killed his family, while at the same time he declared he would end all crime.

This origin happens before his first appearance in comic books in 1974. In *The Amazing Spider-Man* #129, the Punisher is an assassin hired by a villain known as the Jackal to kill Spider-Man. Not an anti-hero, not a vigilante, but a straight-up assassin. Over the course of the issue, Frank Castle came to realize that he

had been tricked by the Jackal. Spider-Man was not a criminal, nor was he an inherent "bad" guy. Even though Frank was an assassin, he still had some sort of moral code—a code, one can assume, made of the last vestiges of the US Marine Code of Conduct, which would have been drilled into his brain as part of his initial training. He wasn't about to murder a straight-up good guy. Later in the issue, Punisher teamed up with Spider-Man, and they took down the Jackal. Thus, Punisher's true comic book origins are revealed.

How could a straight-up villain, a murderous marine, turn himself around to become a figure worthy of admiration and revered by the modern military? Punisher co-creator Gerry Conway once said in an interview that he believes the public perception of the Punisher is indicative of the perception of the military:

"The Punisher as a character is a bit of a Rorschach test in that, as time has passed since his creation, we've gone through different cultural eras and through each of those the character has been reinterpreted to reflect the concerns of society," said Conway, in reference to the end of the Vietnam War and the manner in which many veterans were treated when they came home. "If society feels what we are doing is justifiable, the respect for the military is high, if the society feels guilty or shamed in what we're doing, we project that onto the military."

Based on the sage perspective of the Punisher's co-creator, it can be deduced that the Punisher may be a litmus test for how we judge service members. Remember, at the time of his creation, the Punisher was a veteran of an unpopular war to the citizens of the United States. Service members returned home to be attacked and sometimes brutalized. Now, in the present War on Terror atmosphere, service members are idolized and treated

with much respect, with huge celebrations when they return home from their time overseas. (When I returned home, my plane was driven underneath two fire engines shooting jets of water! It was an astounding honor. I wish all my flights received such recognition now.)

In some ways, by our contemporary mindset, the Punisher can be seen as a hero to modern society. He is a marine who was betrayed by the system. All he retains from his time in the service is a military code of honor and responsibility and single-minded dedication to the mission. The rules of society will not apply to him. The Punisher will hunt down and kill those he deems to be "the bad guys." This is how the general public views the Punisher. Guns blazing. Skull out front and telling the bad guys it's time to get what's coming to them.

However, that fantasy is the smallest percentage of what makes up Frank Castle. His defining characteristic is trauma. When Frank returned home from the war, he had a very difficult time transitioning back to civilian life; most service members do. (I recounted a similar story of my difficult transition back in the War Machine chapter.) It's the contrast of, "How can I go from these very stressful situations where my life is literally in danger every second to the complete opposite? A calm world where your biggest decision of the day might be what color shirt to wear." Compound this transition with the fact that Frank had to witness his family be brutally murdered, and I hope you can see how it would make any person break down.

There's tragic poetry in his origin. Frank finally home from the war. A promise of peace and serenity lies in front of him because he made it home. A calm picnic with his family is yanked away from him in a blast of bullets. Something that should not happen on the home front. Something he fought to ensure would never

happen at home. The blood of innocents spilled in a serene place. It would make Frank believe the war was not over. His missions were lies. The peace he was ensuring never existed. It would make anyone wrap up their hidden PTSD in retribution. He couldn't live without his family. So, when he lost them, he went back to the most comfortable place for him: a war.

On the other hand, I acknowledge that serving during a time of war isn't only brutal for the service member; it also affects the family. Every day, a wife can be terrified of receiving the news her soldier husband has perished. A brother can be stressed and worried to receive the call that his airwoman sister was shot down. For all the external conflicts we service members have in combat, our loved ones have to face battle internally. They fight a war as well.

To worship the Punisher and all that he stands for is to say you are worshipping a man who is hurt. A man who needs help. Nonetheless, rather than offering Frank the help he so desperately needs by way of counseling and/or more, we want to send him back out into the fray. We want him fighting the demons of his mind, projected onto the criminal he believes deserves to be punished. Thinking the deaths of hoodlums and drug dealers will somehow cure his pain. The fandom that has sprung up surrounding this character is confusing to me. It's also, to my mind, quite controversial, but police officers and service members have taken up the Punisher's skull sign as a totem to lead them into battle. Even Chris Kyle, the famous subject of *American Sniper,* admits that his squad had the Punisher skull symbol painted on their equipment. That's fine for soldiers on the front lines of battle, but on the streets of Anywhere, USA, that could lead to some dangerous situations. Could their love for a damaged character be misplaced? Do they not understand the hurt which exists inside this mentally

damaged character's backstory? Or are they obsessed with the masochistic bloodlust of the Punisher? I think it's the final option, sadly, because the Punisher is not a character to praise. He's a character to pity.

While some stories place the blame for Frank Castle's murderous turn on the death of his family, Garth Ennis's story, *Born*, in 2003, hypothesizes that his rage and anger were always there. It was always waiting for a way to be released. The story shows Frank's final tour in Vietnam. Frank is portrayed as a hard captain. Another character describes him as being "in love with war."

I have known many soldiers who were "in love with war." It's a sad side effect that the military draws out of these people. We all know examples of them in our lives. They're the friends who would easily rattle off a statement like "Blow up the Middle East!" A statement so ludicrous and ignorant of the details of the situation, it always makes me facepalm. From my perspective, service members have a duty of protection. To always protect the ideals and the people of their home country. Soldiers are not killers first. Killing should always be the last option. Every soldier on each side wants to go home to their loved ones. None of us want to pull the trigger. It's the absolute last option. Protect the innocent, protect your battle buddies, and protect your ideals; it's the only motto that will get you safely through a war. Anyone who thinks more bullets, explosions, and death will save them is completely insane.

Unfortunately, we see a fully insane Frank Castle in the aforementioned Garth Ennis tale. (I must warn some of my readers about the brief mention of sexual violence. It's sadly a common scene in many Garth Ennis stories.) *Born* reveals what happened during a four-day battle at Firebase Valley Forge, an

outpost on the South Vietnamese-Cambodian border. During his last tour, Frank Castle committed several reprehensible acts. He drowned one of the men in his command when that marine raped a female Viet Cong sniper. Frank shot the same sniper during her rape to put her out of her misery. He continued to lead his squad out on patrols into the dangerous jungle, allowing his squad to slowly be picked off one by one in Viet Cong ambushes. The firebase was due to be closed in less than four days. There was no need for constant patrols. Frank and his men could have safely stayed behind enemy lines. Instead, Frank's drive for violence led them back out into the fray and to their eventual deaths for the possibility of one last engagement. One last fight to possibly satisfy Frank's bloodlust. Well, Frank got his wish. On the fourth and final day, the firebase was attacked. As a result of Frank's patrols, the outpost was undermanned, a military ghost town. It presented the perfect target for the Viet Cong. Under the cover of night, they attacked the fortification, having planned their attack to coincide with a rainstorm to help hide their numbers. The marines engaged in the fight, but wave after wave of Viet Cong stormed over the walls. Frank and his men soon found themselves running out of ammunition. His men began to drop. A pile of bodies overwhelmed the base. So much so, there was no way to determine which body at their feet was a friendly or a foe. Frank found himself alone in the base. He was the last marine standing. His weapon was overheated. It would take a miracle for him to survive. Over the noise of the carnage, Frank could hear a voice in his head. Was this voice imagined? Was this voice real? Smartly, the writer never revealed the truth to the reader. The voice inside Frank's head offered him the strength to survive the night. This battle would not kill him. All it asked for in return was an unknown-to-the-reader price. Frank agreed to this devil's bargain, and the comic cuts away. The next morning, air support finally arrived. The

firebase was now destroyed, with not a single building remaining intact. However, one person did emerge intact: Frank Castle. Atop a gigantic pile of bloody bodies and debris, he alone stood. Frank was bleeding from several gunshot wounds but gave no indication of pain. The voice allowed him to survive the night. It allowed him to kill every single Viet Cong who had invaded his base.

Later, the story hints that the price of survival was the lives of Frank's family back home. This entity forced Frank to give up the only thing capable of ever bringing him happiness in exchange for endurance. However, I have a different outlook on this story. I believe the voice inside of Frank's head was Frank. The carnage and the destruction of the night's events made his mind snap. How could they not? Also, consider that this battle happened toward the end of Frank's third tour in Vietnam. His third tour! Earlier events in the same story proved Frank Castle was not the sanest of men, and when the battle began and fellow marines around him dropped, I believe that voice was Frank's "Punisher" persona. It's the voice that gives him permission to do what is necessary. It's the voice that gives him the out to take bloody and brutal actions when he wants to. It's the voice that tells him what he does is morally right, even though we, as readers, know he's completely wrong. I believe the Punisher was born on that day in this story, and there was no chance of a happy home life for Frank Castle. This is a sad truth for many people who are veterans like him. Sometimes the war is too much.

I never experienced a tragedy like Frank Castle's. I would surmise that most service members don't. However, I have had military experiences that can make me empathize with the Punisher. I went on several dangerous missions. I drove Humvees through bare hills filled with hellacious pitfalls, and my unit lost people. Combat is a symphony of chaos. Danger

surrounds you from every side. Noise fills your every thought, and the only way you can survive is to ignore it all. Just function. It goes against our every human instinct. We want to cower, run, and hide. However, if you do that in combat, you will be killed. Your only chance of survival rests on your becoming a robot, going through the motions of your training, and executing the goal.

That's the way the Punisher operates at all times. Find the target, engage the target, and execute the threat. Yet this is not how a service member should operate in a civilian environment, and that is exactly where all the Punisher's missions take place. Our cities and streets are where Frank hunts his prey.

Frank was a family man. Remember he had two children and a wife? A family he fought through hell to get back to. A family he intentionally took a posting to be closer to. They should be the moral absolute Frank holds to. The Punisher is a collateral damage machine. He doesn't care what buildings get destroyed, or whose father he obliterates, as long as the guilty are punished. I find it very hard to believe the innocent casualty list from the Punisher's actions isn't longer than his guilty list. One cannot operate in a civilian theatre like one does in a combat zone. It's the line I draw on the Punisher. It's the line I know I would never cross. It's a line I believe someone who is hungry for war and damage would. Someone who wants the blood. Someone who was bored with civilian life, family life. Someone who missed the action. That's the Punisher, for me.

Frank Castle is a hurt man. Suffering from his pain, he deems it his mission to take out the ones leading the world to a dark and deadly place. But who the hell assigned him this task? Who in their right mood would pick this damaged service member as the avenging angel of justice?

While Frank has qualities that are commendable—his strength, his decisiveness, and his tenacity—he should not be praised for how he operates. The world is not black and white, like the symbol he wears on his chest. His simple view of the world should not be lauded. Yes, I can see the value in a hero who takes on corrupt officials at all levels, but from my veteran perspective, I also see a very hurt man. I have no desire to celebrate that.

The Punisher is ultimately a dark vision of the breakdown of our society when a war takes over our lives. When we think those in charge aren't looking out for us, we see the Punisher as the ultimate savior. He can get past the red tape; he can right the wrongs with his weapons. Nonetheless, the Punisher is a villain. He should not be cheered on. He should be helped. We can praise his strength and his resolve, but his mission is wrong. Frank Castle does not need more bad guys to kill. Frank needs a hug and support. Why has no one in the Marvel Universe given it to him?

Chapter 15

Deathstroke

The Worst Military Dad

We all have daddy issues. Now, imagine if your father was in the military and he was a world-class mercenary. Also, let's add DC Comics supervillain to that list. Combine all those attributes into one person and I guarantee he's a paternal figure most of us wouldn't be buying a Father's Day card for anytime soon. Well, all those descriptors are accurate of Slade Wilson, better known as Deathstroke: the Terminator. The classic *New Teen Titans* villain with one eye can also be simply described as a real jerk. Slade is one of those characters in fiction who at every turn always makes the wrong decision. When it comes to fighting the Justice League or assassinating a rogue dictator, Slade will always make the right or most tactically sound choice. However, when it comes to his wife or his children, Slade always chooses poorly. Neglecting their feelings, neglecting their birthdays, and forgetting about them altogether in order to run outside the house and murder people. So, as I wrote earlier in this paragraph, a real jerk.

Slade Wilson is an enigma. He's a man who desperately wants to be a family man, a military man, and a mercenary killer, all at the same time—even though each option puts his psyche at odds with the others. You cannot be moral in your duties in the military at the same time you are murdering people for money on the weekends. As to the possibilities of being a good father and being in the military, well, that's definitely possible.

I never had a parent in the military, but my wife has. Her father served in the Canadian military for all his life. He even served as part of the UN peacekeeping force in Bosnia. My wife

remembers him as a great father and their military bases as friendly communities. The only downside of having a guardian in the service was the constant moving around the country. Which I'm sure many military brats can attest to. (As previously stated, "military brat" refers to the children of a service member, or a child that knows another power outranks their powerful parent: their superior officer. For a child, this gives you an advantage over your parent.)

Each of these elements leads to Deathstroke being an interesting and compelling character. At any moment, he could quit all of these vices and become the perfect dad, the splendid officer, and the loving husband. In spite of this, he always chooses himself. His appetite for destruction supersedes his family and his service. Like Walter White from *Breaking Bad*, Deathstroke does it all for himself, he's good at it, and he likes it.

Slade Wilson, when he first joined the military, signed on the dotted line for duty. At the age of sixteen, Slade wanted to enlist in the US Army. (The lowest age for enlistment is seventeen, but that's only with your legal guardian's signed permission.) He was so persistent about joining up and serving his country, he lied about his age to join. Slade quickly rose up the ranks, proving his determination to be the best there was. Soon, he left the enlisted ranks to become a fully commissioned officer and gained the rank of major. His natural talents at being a soldier allowed him to achieve promotion even more speedily. As *Deathstroke* #1 *Volume One*, in 1991, describes him: "He was an American Army legend long before the war."

Think for just one second about what that says about Slade Wilson. He wasn't willing to wait two more years to fight in the military. He was going to find a way into battle, no matter what the rules were. Slade was desperate to prove his worth to the

service. Or was it all a ruse? Was this the classic Slade Wilson
selfishness rearing its head? Did he join driven by an egotistical
desire to confirm he could be the best soldier? I believe so, and
when you consider that it taints every choice going forward, I
think my point is proven. Usually, when a character is in the
infancy of their hero's journey, the audience is introduced to a
purer version of the hero/villain. One that believes in a single
truth. One that has not been corrupted by the years of conflict
and age. From his very first moment, Slade Wilson was neither.
His narcissistic nature conflicted with his core patriotism in his
very first act with the military. For him, it began with a small lie
which would soon become a snowball.

When thinking back on my military career, there is only one
truly selfish act I can remember, or perhaps there is only one
that I will admit to for this book—you decide, true believers! One
of the very first missions I had while deployed in Iraq was to
guard a unit of soldiers that belonged to the US Army Corps of
Engineers. Their specialty was the construction of new bridges,
and I was able to observe the whole process while pointing a
weapon toward the perimeter. On the other side of this river
sat an embedded military unit from Poland. They were lovely
fellows, and I can remember being surprised to come across a
military unit from another country. Perhaps it was naivety or
perhaps I was dumber in my younger years, but many countries
participated in Operation Iraqi Freedom, so this Polish unit
should not have caught me off guard the way it did. They were
a small unit (six men) whose duty it was to help the local Iraqi
Police guard the bridge from insurgents. We later learned this
bridge was one of the main supply routes in the area, which
made it a prime target for terrorism. However, terrorism did
not destroy the bridge; time did. One day, a giant section of
the bridge fell into the river below, thus necessitating the
progression of our mission. The Army engineers obliterated the

remains of the old bridge with all speed and set about assembling a temporary bridge which floated on the surface of the water. This allowed for the passage of a single line of traffic over the river, while construction began on the new permanent structure. It was our duty to guard the vehicles crossing, to make sure the engineers worked uninterrupted.

Several of the Polish soldiers would come out and join our patrols, giving us an extra hand and making our job slightly easier each day. We awaited the engineers' completion of the project so we could zoom back to our warm beds (actually flat Army cots) in the tent that was home for the course of our deployment, and not the cold, cramped, and dusty Humvees parked on the desert, which had become our quarters for the duration of the mission.

When the bridge was finished, the Polish soldiers invited all the American soldiers to a grand feast, which was actually a small sampling of their rations mixed with bottles of liquor. In my experience, this was an uncommon occurrence, so of course, we all wanted to attend. Our commanding officer forbade us to go because he claimed we had too many duties to attend to. In truth, we had no duties. Our only job at that point was to pack up our gear and continue security duty. So, I snuck over to the feast and enjoyed a few drinks with our new Polish friends. Was it selfish? Very much so, but I did at least have the decency to check in with my battle buddy and ensure that he could cover me on the perimeter in case something hairy happened. At the time, it seemed like I would never have an opportunity presented to me like this again. A friendly feast with fellow soldiers from across the world to celebrate a job well done? I'm glad I betrayed my orders and went.

At least my selfishness wasn't a betrayal of federal paperwork the way Slade Wilson's was. Deathstroke would continue his disrespect of the rules when he met another fellow soldier, Captain Adeline Kane. Captain Kane was an instructor for the Army Special Forces. Her training was brutal. Most recruits couldn't make it through her training, but Slade did. She taught Slade to stop thinking one-dimensionally. Threats may attack from any direction. Your brain must be ready. Your mind must prepare for any threat. This line of thinking is very similar to another DC Comics hero, Batman. Adeline broke Slade of his reliance on weapons. She forged his body into a weapon of its own. Slade graduated her training with honors, and it wasn't long afterward that these two Army officers began a relationship. They were married in less than a year. Shortly afterward, Slade was sent into battle to use his new techniques in the field and do what he had been trained to do. Slade left behind his new wife, who could not deploy due to the imminent birth of their son, Grant. Technically, Slade had again broken the rules by pursuing his relationship with Adeline Kane. His selfish desire had gotten in the way of proper protocol and command. According to Army Regulation 600-20, "relationships (both opposite-gender and same-gender) are prohibited if they: Compromise, or appear to compromise, the integrity of supervisory authority or the chain of command." Remember from the Batwoman chapter? Since Slade and Adeline's relationship began during their training, their lovemaking was against the rules. Adeline was his superior training officer. He may have come to outrank her, but for the purposes of his training, she was the boss. Their relationship could have compromised the validity of the training, or Adeline could have given Slade preferential treatment, which she most definitely did. There is not one section of Deathstroke's life in which he will not bend the rules to his will.

As a quick aside, I can confirm that fraternization in the military is actually quite common. Between many ranks and units, romance does bleed through the uniform. However, in the many cases I knew about, no one was this open about their fraternization, and it never led to marriage like Slade and Adeline.

After his wartime missions, Slade was asked by the military brass to volunteer for a top-secret mission. It was pitched to him as an experiment to help soldiers defend against enemy truth serum, but that was quickly revealed not to be the truth of the matter. The government wanted to create metahuman super soldiers. Slade Wilson, being one of their best men, was the perfect test subject. Just like with Captain America, and many of the other superpowered soldiers in this book, comic books like to present the leaders of the military as corrupt officials who play fast and loose with human life. It's interesting that this seems to be a common trope lobbed at military leaders across comic books. Could it be most comic book writers are averse to government leaders? Do they believe there is no way government leaders would not try to experiment on common people to further military goals? They are partially correct. We have seen plenty of corruption in the military in the past, but Slade Wilson is only one of several super soldier experiments in comics. One does wonder what started this common corrupt-military-leaders theme.

During the experiment, Wintergreen, a fellow soldier and good friend of the Wilsons', tried to convince Slade to step away from the experiment. He was already the best soldier in the US Army. He had nothing to prove to anyone. Slade's selfishness took over. He sent his friend away with a laugh. He was incapable of fathoming what could possibly go wrong with the experiment. Soon, Slade was strapped to the table. The

needles full of the ACTH serum were inserted into his arms, and moments later chaos erupted. Slade broke the straps with a newfound superhuman strength. It took several military policemen to contain him. The damage was done. The old Slade Wilson was gone.

Slade would later have to be confined to a bed and regularly sedated in order to curb his aggressive, dangerous nature after the accident. He was held prisoner in a room during the birth of his second son, Joseph Wilson. It would be quite some time before Slade eventually discovered the experiment had worked. All his pain, suffering, and confinement granted him enhanced speed, strength, reflexes, and stamina beyond any mortal man. As a result of his violent outbursts, Slade had to be restricted to Army desk duty. He sought out professional hunting and mercenary work to fill the need for violence in his life. He yearned to fight and viewed himself as one of the best fighters in the world.

Slade finally accepted his supervillain identity when his best friend, William Randolph Wintergreen, was captured following a dangerous suicide mission. When the military refused to rescue Wintergreen, Slade put together a costume and set out to save his friend. He succeeded but was discharged from the Army for disobeying orders. Slade saw his discharge as a good thing. Fed up with the orders and code of conduct he felt hampered him from completing his objectives, Slade named himself "Deathstroke: the Terminator."

To become a mercenary is an interesting career path. You agree to fight in military conflicts and take on precarious missions only for the payday. No political interests or governing body gives you your orders; private companies or individuals do. In modern warfare, those orders are usually given by private security firms.

I met a group of mercenaries during my time in Iraq. Their supply hub and warehouse were located on the base where I was stationed. They were nice guys. However, they were always armed to the teeth on base, and each individual carried more live ammo than any soldier I saw throughout my entire deployment. These were some badass men. We traded beers and stories one night, but I never asked them how much money it took for these tough gentlemen to journey into a war zone. For myself, such a paycheck would have to be quite high.

For Slade Wilson, it turned out the price was very low. Yes, his rates for the services of Deathstroke were quite enormous. He soon became the greatest assassin in the world, which meant he did not have low rates. No, I'm talking about his personal price. The one he levied against his soul. To keep killing, to cross borders and enter conflicts without orders, and to betray the Army core values he swore to uphold—that was the price he had to pay. Slade enjoyed his new career as Deathstroke, even putting his own life on the line time after time, despite his now being the father of two young children. All the while, he never told his wife about his extracurricular activities.

That's right—Adeline had no idea Slade was Deathstroke. It's not clear if Adeline even knew what Deathstroke was. Nevertheless, Slade put on his mask night after night to quench his selfish desire for violence while simultaneously putting his entire family at risk. He tried to justify his actions as Deathstroke by creating a new code of honor for himself. He would never betray the people who hired him, and he would never execute anyone he believed to be innocent. It's a thin code of honor, but when you're the murderer of hundreds of people, you can justify anything to yourself. Especially when you are constantly driven toward violence, toward bloodshed.

Deathstroke was later hired to kill a colonel in the Qurac military (Qurac being one of the fictional nation-states that exist in the DC Comics Universe). Slade completed the mission and never gave it a second thought, until an assassin by the name of the Jackal kidnapped his youngest son, Joseph. The Jackal wanted the identity of the person who had hired Deathstroke to kill the colonel. Slade was so arrogant about his metahuman abilities that he gambled with the life of his son. He stormed the Jackal's facility and was able to kill all of his son's kidnappers except one. This enemy slit Joey's throat seconds before Slade could bring down the killing stroke. Slade rushed Joey to the hospital, where he was forced to finally tell his wife, Adeline, about his secret life. He had to admit to all his secret murders. His careless actions led to permanent vocal damage for their son, Joey, who remained mute for the rest of his life. Adeline became enraged. She had been betrayed by the man she loved. The same man who had almost gotten one of her children killed. This momma bear picked up a gun—literally—she aimed it at Slade's face, and she fired! Slade managed to dodge the bullet at the last second, thanks to his abilities, but not fast enough for the bullet to avoid his right eye. Slade lost sight in his eye and lost his wife, as Adeline quickly divorced Slade.

(There are several different versions of how Slade Wilson loses his eye in many DC Comics stories and television shows. The original comic version is the one I think is the most emotionally resonant.)

Deathstroke would go onto become a foil for the entire DC Universe, primarily through the lens of his nemesis status to the team known as the Teen Titans. He would blame them for the death of his eldest son, Grant, who dressed up as the Ravager and followed in his father's footsteps. This back-and-forth battle of wills with the Titans would continue for several

years, although it often changed and adjusted based on Slade's current view of his enemies. Sometimes he would go so far as to team up with the Titans, but mostly he crept in the shadows of the DC Comics universe, a secret assassin who could take down any target.

Slade Wilson would tell you he was a good man, in the grand tradition of many comic book supervillains. The best villains are always the ones who think they're right, who have a skewed perspective and commit heinous acts in pursuit of their "righteous" goal. It's actually similar to a service member having to defend lethal actions in time of war to a civilian. Some would make the argument that killing is an absolute no-no; however, in a time of war, with your boots on the ground, when it's between the protection of the unit and the life of an enemy combatant, you have to make the hard choice. It's a difficult moral area.

That's what makes Slade Wilson an interesting character. Slade would never murder an innocent and, because of that, he's a better man than some of the other monsters, like the Joker or Lex Luthor, who he shares the DC Universe with. For my money, he's their equal. His obsession with killing led him past the point of no return. Slade betrayed the code of honor of the military, he betrayed his own morals, and he betrayed his own family. The last one ought to be considered the worst of his crimes. His selfishness cost him a woman who truly understood him, a woman his equal in all things military, and who could understand his troubles and concerns in that realm. Instead, he threw it all away.

Some would say it was the experiment that changed Slade into this monster. I would counter that this side of the character was always there, similar to Frank Castle, the Punisher. Deathstroke, from the very beginning, would walk into any situation and

immediately toss the rules aside to suit his needs. Look back to the very first time he enlisted. He couldn't wait two years to serve his country. Serving in the military is about more than duty and honor. It's also about perseverance. Can you hold out for the long term? It's the only thing that can keep you sane during long engagements or deployments. Slade Wilson could not. Not in his personal life and not in his military career. He was never a patient man. He didn't care about joining up like everyone else. Slade deemed himself better than the rest. He deserved to have more than you, more than anyone else. That makes him a selfish man. That makes him a villain.

Chapter 16

Nick Fury

Obsessed with Fear

Only one man could command and control the Howling Commandos: Nicholas Joseph Fury. (Also, it felt fitting to make the final chapter of this book about the man who once gave orders to Captain America, the subject of the opening chapter.) Published four years after Sgt. Rock in 1968, Nick Fury first appears as Marvel's direct copy of DC's tough growling commando. However, the many years and transformations have cemented Fury as one of comic books' greatest superspies and a deep, complex character. Most comic fans think of Nick Fury as a spy, rather than a soldier. It's not surprising that the Marvel Cinematic Universe has never hinted at the character's history as a war veteran. Keeping him a superspy who will do anything to obtain his outcome, the ends always justifying the means, helps to distance him from Captain America.

Nick Fury was born in the area of New York known as Hell's Kitchen (which would later become the comic book neighborhood protected by Daredevil!). He was twenty years old when he was drafted into the US Army to fight in World War II. Fury was a competent soldier and never minded the tough missions or rough conditions of the military. His ability to put his head down and his "get the job done" attitude led to a series of promotions. Before he knew it, Fury was a sergeant. He was offered the command of a unit of highly trained soldiers, the Howling Commandos. This unit would later go on to fight alongside Captain America, the Invaders, and even the mutant Wolverine.

Nick Fury's command style was shrouded by fear. Even in the first issue of *Nick Fury and his Howling Commandos* in 1963, the reader learns: "Fury believes in making his men fear him so much that they would rather face hopeless odds than face his anger." This strategy would benefit him later in life when he became a spy. Overall, the Howling Commandos were not so much a strike team but more a goofy collection of soldiers who could barrel through any problem, usually by devising a solution at the last minute or having Fury yell the right combination of orders at them. One unique aspect of this team was its integrated nature, which was uncommon at the time. Also, the Commandos counted Private Cohen among its ranks, one of the first Jewish-American comic book heroes. Fury was a stereotypical Army leader. Most of his stories were classic action-adventure stories. There was never anything too deep about this group of battle-hardened heroes. For all his brusqueness, or perhaps because of it, Fury was still able to bring every one of his men home alive. The only member of the Howling Commandos that did not survive was his left eye. (Deathstroke and Fury are both members of the one-eyed soldiers club.) This eye was taken away by a grenade blast that hit Fury toward the end of the war. Fury began wearing an eyepatch, a physical characteristic that is an iconic look for the character, thanks to the Marvel Cinematic Universe. Even though he was not a disabled veteran, Nick Fury was about to walk into a treasure trove beyond imagining. The Howling Commandos were offered injections of a serum called the Infinity Formula. If taken annually, this chemical would greatly slow the aging process. Like any other sane person, Nick Fury volunteered and gained a long and healthy life.

In 1967, writer Jim Steranko began to redefine Nick Fury. It was the age of James Bond, not the war comic, and Steranko transformed Fury into a secret agent who also happened to be a dynamo with the ladies. It fit the trend of the time and gave

a new story element to a very tired war character. Previously, Fury was a cliché, a simple archetype. With Steranko's dynamic storytelling, Fury ascended to a whole new level entirely. His rise was propelled by Jim's groundbreaking art—mixing pop art and psychedelia. The secret agent tales of Nick Fury soon became his most popular stories.

Future Nick Fury stories would keep him in the secret agent realm as he began to recruit several of his old friends, including Richard and Mary Parker, the parents of Spider-Man, to join him in a new organization called SHIELD. Originally, the acronym stood for Supreme Headquarters, International Espionage and Law-Enforcement Division, but the acronym—like Fury himself—has changed several times since. This comic book superspy organization made James Bond's MI6 looks like child's play. They had Helicarriers, floating aircraft carriers capable of circling the world, and flying sports cars at Fury's command! He began to rally the many superhero teams into working alongside his new spy organization. Policing them, corralling them, and blocking them from many actions he deemed unsafe for the civilian populace quickly became his full-time job. This Fury still operated as an agent of fear, and his new organization gave him the power to take care of anything he deemed a threat without oversight or consequences.

There are many similarities in the soldier and spy games. Soldiers must be ever vigilant while in the field, the same as a spy. One simple mistake could lead to the end of your life. However, a soldier's battle eventually ends. For a spy, there is always a new threat, a new terrorist, or new nation-state to endanger whatever way of life your organization is dedicated to protecting. Both occupations are built around the chain of command and the centralization of information. I would also contend that most fictional spies do not come off as honorable as

soldiers. Even Nick Fury, in certain storylines, has assassinated people and threats without hesitation. Think about the countless assassin missions we've seen James Bond complete, probably the world's most famous example of a spy. He's not afraid to break the rules in many places where a service member would hold the line.

Briefly, I flirted with the idea of joining the CIA. It was during a period in my life when I wasn't certain what avenue I was going to take. Was I going to be a writer, was I going to be a teacher, or was I going to be a lawyer? All of these occupations had different trials, and each offered exciting possibilities to my young career. Then I saw an ad for the CIA. I furiously typed in the website. Notions of being a superspy like Nick Fury danced in my head. I could do that! Surely, I wouldn't have to work at Quantico all year long. They'll send me to the exotic locales of Europe within days, just you see! I soon discovered the entrance exam to join the fabled organization. It looked complicated, it looked very long, and it soon brought me to a realization: if the entrance exam was this complicated and mundane, then that was probably what the rest of the organization would be like. Days in the CIA aren't like the movies of James Bond. It soon dawned on me that, by joining, I would be signing up to fill out a ton of paperwork about foreign nations, something that I had no interest in. My fabled career track to SHIELD was over before I knew it.

War was never over for Nick Fury. Like the Punisher in his chapter, Nick couldn't let his war end. He was seeking it out, judging the oncoming threats, and thinking outside the box to predict where the next biggest danger would come from. He was consistently over-prepared for unseen hazards. Nick Fury was one of the first Marvel Comics characters to predict the oncoming Skrull invasion during the comic event *Secret Invasion* in 2008. The Skrulls are green, pointy-eared aliens

with the astounding ability to change their shape and look like anyone you know. Imagine Kermit the Frog, except with a really bad attitude and the drive to conquer innocents. Nick Fury is a powerful man in the Marvel Universe, but he's also one of the most paranoid. So of course, when the Skrull Empire sent one of their shape-changing agents to capture and replace Fury, he was able to predict their movements and subdue the Skrull agent. He interrogated the creature and discovered a Skrull invasion was coming. Fury didn't know when. Still, he prepared. He ghosted his position as the head of SHIELD and began to recruit. Similar to his World War II Howling Commandos, Fury gathered a team. He trained with them for months, motivating them with fear. Why? On the grounds that this Skrull invasion would be the most impossible situation Earth could ever face. This old Army veteran had to make sure his ducks were in a row; his soldiers were more than ready to handle the threat and ensure he could beat anything the Skrulls might throw his way. Because he was afraid. When the Skrull invasion came to Earth, Fury named his soldiers the Secret Warriors. They joined the battle with the Avengers. Earth's Mightiest Heroes were happy to have an ally. However, Nick Fury and his Secret Warriors teleported away as soon as the battle was won. They were ready to find the next threat. Fury had decided to permanently operate from the shadows. To be the ultimate "break glass in case of emergency" team for Planet Earth.

Nick Fury is ultimately a flawed man. A man who weaponizes his own internalized fear as a motivator for the people under his command. Sometimes it works and motivates them, but mostly it drives them away, forcing them to view Fury as an obsessive paranoid.

The overall view of his entire career can also be seen as a meta-commentary on America. Whether or not it was planned that

way in the beginning, just like America, Fury fought a simple battle in World War II. His mind and career expanded to fight a subtle battle against the communists in the Cold War, and his paranoid suspicion of the men in charge post-Vietnam led him to build his own organization. Eventually, he became a free agent and operated without rules like the Punisher. Every American war and conflict has a man like Nick Fury—a man driven by fear, but always willing to do what is needed get the job done. In fact, if Nick Fury does his job properly, he's able to save the day, and you won't even know he's been there.

To all the Nick Furys out there, currently reading this book in search of future threats, I salute you.

Honorable Mentions

If you've made it this far into the book, then I want to extend to you my genuine thanks for not immediately tossing it into the closest trash bin, deeming its clunky prose beneath you. Climbing over the hill of this book took several hours of research and exposed me to several characters and stories I hadn't read in a very long time. I hope you were able to gain new appreciation for these comic characters the same way I did.

Whittling down the list for which service members were going to be featured in the book was one of the toughest tasks I faced. It soon became a *Sophie's Choice* of which character got featured and which had to be cut. Thankfully for you, and unfortunately for my editor, I have stumbled onto the fabled and unsung hero of the novel: an extra chapter.

Please find below some marines, airmen, sailors, and soldiers that I couldn't find space for in the main part of this book. In no way am I contending these characters were not worthy of a full chapter; all of them are. If your favorite military character is below, then I humbly apologize to you and its creator for sticking it in the back of my book. Please contact the publishing company for a location to direct your assassins toward. As I await my demise, let's sally forth to the service members who are more than worthy of mention.

Wolverine

Yes, I know that the mutant Wolverine was the veteran of several wars! My only knock toward not including him was the fact that he served in the Canadian military. No, I'm not opposed to

foreign armies, and I believe their service is just as valuable as the US military. However, this book needed focus and limiting it to characters who served the United States allowed me to do that.

James Howlett, a.k.a. Wolverine, fought in World Wars I and II and, in some continuities, the American Civil War, the Vietnam War, and the first Iraq War. As a result of his regenerative healing factor and slow aging, he's probably fought in more wars than any character in this book. Still, I decided not to include him.

His tenacity and grit were not in question. His love of war and mayhem was. Many of the stories featuring Wolverine in war are focused on the number of people he kills. When you take Wolverine off the chain, he can end conflicts simply as a result of the sheer number of people he murders. Plus, it's a well-known fact that Wolverine did not calm down from his murderous tendencies until he met Professor Xavier and his famous X-Men, several years after all his wars.

While Wolverine's courage is not being questioned, the quality of his service is. A soldier being ascribed an animal instinct is an abominable quality and unworthy, in my eyes, of earning a full chapter.

John Diggle

One of the more recent additions to DC Comics' continuity is John Diggle. Created for the CW show *Arrow* in 2012, John is a bodyguard whose selection of skills makes him a perfect partner and best friend for Oliver Queen. His backstory revealed that he was a part of Special Forces in the Afghanistan War. Not only

was John an outstanding soldier, loyal, courageous, and brave, but he met his spouse Lyla while serving as well!

The character became so popular on TV that DC Comics eventually decided to include him in the comic continuity, where he became a main character during Jeff Lemire's *Green Arrow* 2013 comic run. Comic book Diggle features many of the same characteristics as John on the CW, and he quickly became Green Arrow's backup whenever he found himself overwhelmed. An excellent example of using military service as the foundation upon which to create a powerful new character.

Wonder Woman

Diana, Princess of Themyscira, is a mystical Amazon with superpowers and abilities far above the average person. Her loyalty lies with her homeland and in protecting the fabled Paradise Island from harm or mystical threats. I know what you're saying. "She didn't serve in the US military, that's why she's back here."

Wrong! When Wonder Woman was first introduced in *Sensation Comics #1* in January 1942, she took up the secret identity of an Army nurse named Diana Prince. This identity even carried over into the Linda Carter television series, where we see Diana posing as an Army nurse in the pilot episode.

This Amazonian warrior didn't stay an Army nurse for very long because she had to deal with the Justice Society of America relegating her to team secretary, despite her powers ensuring that she was the strongest member of the team! Luckily, she would serve as leader of the Justice League in future storylines,

no thanks to those 1940s male stereotypes. Be more progressive next time, fellas.

Steve Trevor

The DC Comics airman who crash-landed on Paradise Island and brought Wonder Woman into the modern world. He's been a member of the Army, the Air Force, a Navy SEAL, and a secret agent, depending on who is writing the story. Besides not being consistent in his origin, the man is constantly upstaged by the better warrior and soldier named Diana.

Unknown Soldier

This is the one character I fought hard to keep in the main section of the book. The Unknown Soldier is another DC Comics character who was introduced during the original run of their magnum opus war comic, *Our Men at War*. Meant to be an interpretation of the Tomb of the Unknown Soldier at Arlington National Cemetery, this character is a perfect cipher for all the men and women who fight in armed conflicts but receive none of the praise.

Like Nick Fury, this soldier was more of a spy than a soldier, using uncanny *Mission: Impossible*-level disguises to foil Nazis and enemies alike. His one weakness is that the disguises could not stay on his face too long because he had scar tissue on his face that he would normally hide under bandages.

I decided to keep the Unknown Soldier unknown due to the fact that he has an immense temper. I felt this trait was better represented by other characters.

Captain Willie Shultz

Willie Shultz is the loneliest soldier in any war, a Charlton Comics character who first debuted in *Fightin' Army* #76 in October of 1967. Willie is unique among comic characters who fight in World War II. He's a German American. Willie's conflict starts in his genes! He ascends to the rank of captain and then is falsely accused of murder. Willie's solution to avoid his bogus rap? Blend into the German army!

Willie was a soldier whose battle was not on the fields of France, but inside himself. He had to contend with a battle of loyalties. An interesting character with an interesting journey and arc. I cannot say more without spoiling his story, so I would invite you to seek out more Willie Shultz.

The Comedian

Edward Blake was murdered in 1986. His death kicks off the events of Alan Moore and Dave Gibbons' famous graphic novel called *Watchmen*. His superpowered allies search for his murderer and discover the shocking conspiracy buried at the core of their world. The Comedian was a brutal man with a sadistic love of war. He liked the power it brought him. The ability to take and steal from the countries he was ordered to invade. A personification of nihilism.

Deciding to exclude him from this book at large ensured I
would not have to compete with the legendary prose powers
of Alan Moore, a battle I would not have won. Plus Mr. Moore
is a wizard. Seek him out for more conversations about
the Comedian.

Spawn

Al Simmons was a highly decorated marine who became a black
ops CIA member after he left the Corps. After he was brutally
murdered, he made a deal with the devil to return to Earth and
his wife. Al found himself back on Earth, clothed in a magically
powered hell spawn and a giant red cape. Naming himself
"Spawn," this Todd McFarlane creation fights demons and
ponders his old life while holding a human skull in his hands à
la *Hamlet*.

Personally, I felt the story of Spawn and his military experiences
was better told through other characters like Deathstroke. But I
still like his cape!

The Losers

One of the most famous groups in DC Comics war comic
publishing renaissance, this group of service members with the
worst luck ever were first featured in *G.I. Combat* #138 in 1969.
These "losers" were allies of some of the other DC war characters
I featured in this book, including Sgt. Rock and Gravedigger.

While I was intimidated about writing about a singular character,
I became shell-shocked when considering the monumental

task of trying to compose a ripping lesson about this comic supergroup. It's very easy to get to the heart and legacy of a singular character. Trying to figure for a whole group of amazing men and women? Near impossible. To Captain Johnny Cloud, Gunner, Sarge, Captain Storm, and Ona Tomsen, I have failed you. May you continue to "lose" in the great beyond of comic book Valhalla.

Skyrocket

Lt. Celia Forrestal is a US Navy aviator created by Kurt Busiek in *JLA #61* in 1997. Using an invention called the Argo Harness that was constructed by her parents, Celia harnesses energy to fight off terrorists. Her patriotically-colored armor was designed by the legendary Tom Grummett, and her character hasn't been seen in many DC Comics issues. This is something I hope they rectify soon.

Moon Knight

Marc Spector is a Marvel Comics character who left the US Marines quickly and became a mercenary. When he was left for dead on one of his missions in Egypt, he was carried inside an ancient temple to the moon god Khonsu. Marc speaks to the moon god and agrees to become his avatar on Earth in exchange for a second pass at life. He becomes the Moon Knight

While the character has an interesting costume and design, Deathstroke has a more compelling mercenary story.

Queen

Her real name is Adriana Soria. She was the first female marine in combat during World War II, and she soon became yet another attempt by scientists in the Marvel Universe to recreate the Captain America super soldier experiment. Adriana finds herself essentially immortal with the ability to control insects in the present.

While her World War II history is worthy of mention, the character's storyline gets muddied with each subsequent storyline, where she is turned into more of a magical supervillain with no connection to her military past.

Skateman

Billy Moon is a Vietnam veteran who decides to wrap a scarf around his face and fight crime on his roller skates. The less said about Skateman, the better.

Acknowledgments

This book, like war, was a constant battle. Writing a book like this while I had a full-time job, weekly podcast, and YouTube channel was very challenging. At every turn, I doubted my writing ability, I doubted my picks, and I doubted that anyone would ever read this tome. Thankfully my wife, Ashley Victoria Robinson, talked me off the ledge every single time. She's my biggest cheerleader. Without my marriage to her, this book would have never happened, so I'm deeply grateful to her.

Secondly, I have to give eternal thanks to my mother. Not only did she birth me into the world (you're welcome, universe), but she also birthed in me a love of reading. Constant trips to the library to grab the next literary adventure were her ideas, so I thank her for starting me on the path that eventually led to this book you now hold in your hands.

I would be remiss to not thank the creators, writers, artists, inkers, colorists, letterers, editors, and anyone else that had a hand in the creation and stories of my seventeen comic book service members. It has been a privilege to read their collective work and share it with you, my readers.

A book is not built by one person alone. Thanks to the assured hand of my editor, Hugo Villabona, I was able to keep this book narratively on track. The rest of the staff at Mango Publishing were especially generous with their time and my multiple requests to devote more time to research!

Special thanks to Alicia Malone, who, because of a random email, connected me with the fine people at Mango and made this book possible. I owe her my firstborn. Not certain if she'll want to collect, but the offer stands.

Lastly, I must shout my admiration for my little brother, Matthew, who now, as a newspaper reporter, constantly pushes me to reconsider and challenge myself to go further and further.

Here is a list of generous friends and colleagues who assisted me with ideas and praise and/or offered aid in times of peril during the completion of this book: Kate Allred, Joshua Hale Fialkov, Jeremy Skinner, Nathan Alexander, Anthony Swofford, Jeffrey Bridges, Susan Bridges, Matthew Peterson, Stephen Schleicher, Mark Reilly, Mimi Won, Michael Falk, Hope Masters, Jovan Robinson, Jace Milam, Erik Burnham, Alex Segura, JonBoy Meyers, Kendall Sherwood, Meghan Welsh, Craig Sweeny, Michael Angeli, Nicola Scott, Mitch Gerads, and Denise J. St-Pierre.

Further Reading by Subject

Captain America

Kirby, Jack, writer. *Captain America by Jack Kirby Omnibus*. Marvel Comics, 2011.

Gruenwald, Mark, writer. *Captain America: The Captain*. Marvel Comics, 2015.

Waid, Mark, writer. *Captain America: Man Out of Time*. Marvel Comics, 2011.

Gravedigger

Various authors. *Showcase Presents: Men of War*. DC Comics, 2014.

Wein, Len, writer. *DC Universe: Legacies*. DC Comics, 2014.

Captain Marvel

Deconnick, Kelly Sue, writer. *Captain Marvel Vol. 1: Higher, Further, Faster, More*. Marvel Comics, 2014.

Bendis, Brian, writer. *Civil War II*. Marvel Comics, 2016.

Stohl, Margaret, writer. *The Life of Captain Marvel Book One*. Marvel Comics, 2018.

War Machine

Kaminski, Len, writer. *Iron Man: War Machine*. Marvel
 Comics, 2008.

Benson, Scott, writer. *Iron Man/War Machine: Hands of
 the Mandarin*. Marvel Comics, 2013.

Benson, Scott, writer. *War Machine Classic—Volume 1*.
 Marvel Comics, 2010.

Slott, Dan, writer. *Tony Stark: Iron Man Vol. 1: Self-Made
 Man*. Marvel Comics, 2019.

Green Lantern (John Stewart)

Jones, Gerard, writer. *Green Lantern: The Road Back*. DC
 Comics, 2003.

Various authors. *Green Lantern: War of the Green Lan-
 terns*. DC Comics, 2012.

Tomasi, Peter J., writer. *Green Lantern Corps Vol. 1: Fear-
 some*. DC Comics, 2011.

Captain Atom

Bates, Cary & Greg Weisman, writers. *The Fall and Rise of
 Captain Atom*. DC Comics, 2017.

Krul, J.T., writer. *Captain Atom Vol. 1: Evolution*. DC
 Comics, 2011.

Green Lantern (Hal Jordan)

Giffen, Keith, writer. *Green Lantern: Emerald Dawn*. DC Comics, 1991.

Johns, Geoff, writer. *Green Lantern: Rebirth*. DC Comics, 2010.

Johns, Geoff, writer. *Blackest Night*. DC Comics, 2011.

Flash Thompson

Remender, Rick, writer. *Venom by Rick Remender: The Complete Collection Vol. 1*. Marvel Comics, 2011.

Various authors. *Spider-Man: Brand New Day: The Complete Collection Vol. 2*. Marvel Comics, 2016.

Isaiah Bradley

Morales, Robert, writer. *Truth: Red, White & Black*. Marvel Comics, 2004.

Sgt. Rock

Kanigher, Bob, writer. *Sgt Rock Archives Volume 1*. DC Comics, 2002.

Kanigher, Bob, writer. *Showcase Presents: Sgt Rock Vol. 1*. DC Comics, 2007.

Batwoman

Rucka, Greg, writer. *Batwoman Vol 1. Elegy*. DC
Comics, 2013.

Williams III, J.H., writer. *Batwoman Vol 1: Hydrology*.
DC Comics, 2012.

Tynion IV, James, writer. *Batman—Detective Comics Vol
1: Rise of the Batmen*. DC Comics, 2016.

Beetle Bailey

Walker, Mort, writer. *The Best of Beetle Bailey*. Easton
Press, 2005.

Walker, Mort, writer. *Beetle Bailey "The First Years:
1950–1952."* Checker Book Publishing Group, 2008.

Nuke

Miller, Frank, writer. *Daredevil: Born Again*. Marvel
Comics, 2014.

Remender, Rick, writer. *Captain America Vol. 3: Loose
Nuke*. Marvel Comics, 2014.

The Punisher

Ennis, Garth, writer. *The Punisher: Welcome Back, Frank.* Marvel Comics, 2002.

Ennis, Garth, writer. *Punisher: Born.* Marvel Comics, 2003.

Ennis, Garth, writer. *Punisher: The Platoon.* Marvel Comics, 2017.

Deathstroke

Wolfman, Marv, writer. *Deathstroke: The Terminator Vol. 1: Assassins.* DC Comics, 2015.

Priest, Christopher, writer. *Deathstroke Vol. 1: The Professional. Elegy.* DC Comics, 2016.

Nick Fury

Steranko, Jim, writer. *S.H.I.E.L.D. By Steranko: The Complete Collection.* Marvel Comics, 2013.

Harris, Bob, writer. *Nick Fury, Agent of S.H.I.E.L.D. Classic Vol 1.* Marvel Comics, 2015.

Hickman, Jonathan, writer. *Secret Warriors Vol. 1: Nick Fury, Agent of Nothing.* Marvel Comics, 2009.

About the Author

Jason Inman is a Kansas farm boy who read too many comics and science fiction novels as a child. Luckily, he was able to turn that into a career.

He is the co-creator and co-writer of *Science!* for Bedside Press and *Jupiter Jet* for Action Lab Entertainment. Jason was the host of *DC All Access*, DC Comics official web series, for over three years. Besides having written for several comic and entertainment websites, Jason has produced and written for web shows including *Good Mythical Morning* and *Screen Junkies*.

Prior to becoming a writer, Jason served in the US Army and Kansas Army National Guard, deploying as part of Operation Iraqi Freedom.

When not posting weekly episodes of his podcast, *Geek History Lesson* or content on his Youtube channel, youtube.com/jawiin, Jason can be found searching California for old cowboy towns.

You can find him on Twitter @Jawiin or at his website, jawiin.com